Focus On Photographing People

The *Focus On* Series

Photography is all about the end result—your photo. The *Focus On* series offers books
with essential information so you can get the best photos without spending thousands
of hours learning techniques or software skills. Each book focuses on a specific area
of knowledge within photography, cutting through the often confusing waffle of
photographic jargon to focus solely on showing you what you need to do to capture
beautiful and dynamic shots every time you pick up your camera.

Titles in the *Focus On* series:

Focus On
Photographing People

Haje Jan Kamps

AMSTERDAM • BOSTON • HEIDELBERG • LONDON • NEW YORK • OXFORD • PARIS
SAN DIEGO • SAN FRANCISCO • SINGAPORE • SYDNEY • TOKYO

Focal Press is an Imprint of Elsevier

Focal Press is an imprint of Elsevier
30 Corporate Drive, Suite 400, Burlington, MA 01803, USA
The Boulevard, Langford Lane, Kidlington, Oxford, OX5 1GB, UK

Notices

Knowledge and best practice in this field are constantly changing. As new research and experience broaden our understanding, changes in research methods, professional practices, or medical treatment may become necessary.

Practitioners and researchers must always rely on their own experience and knowledge in evaluating and using any information, methods, compounds, or experiments described herein. In using such information or methods they should be mindful of their own safety and the safety of others, including parties for whom they have a professional responsibility.

To the fullest extent of the law, neither the Publisher nor the authors, contributors, or editors, assume any liability for any injury and/or damage to persons or property as a matter of products liability, negligence or otherwise, or from any use or operation of any methods, products, instructions, or ideas contained in the material herein.

Library of Congress Cataloging-in-Publication Data
Kamps, Haje Jan.
 Focus on photographing people / Haje Jan Kamps.
 p. cm.
 ISBN 978-0-240-81469-8
 1. Portrait photography. I. Title.
 TR575.K26 2011
 778.9'2—dc22
 2010045036

British Library Cataloguing-in-Publication Data
A catalogue record for this book is available from the British Library.

ISBN: 978-0-240-81469-8

For information on all Focal Press publications
visit our website at *www.elsevierdirect.com*

11 12 13 14 15 5 4 3 2 1

Printed in China

Typeset by: diacriTech, Chennai, India

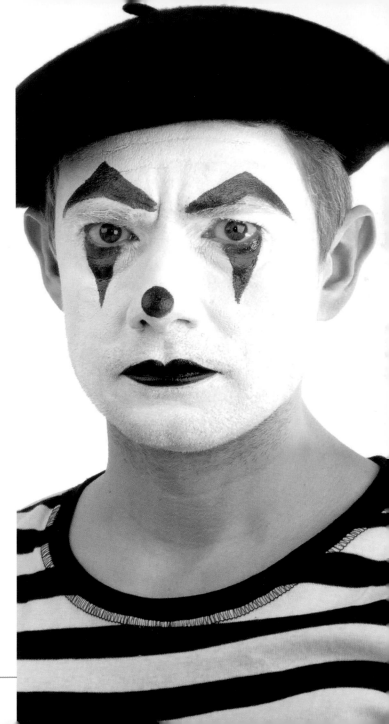

Dedication

For Ziah. Here's to many miles still to go.

About the Author

Haje Jan Kamps lives in London, where he writes books and blogs about photography, takes photos, and rides his motorcycle.

Acknowledgments

I would like to thank Stacey Walker at Focal Press for all her invaluable advice in writing this book. Also, this title wouldn't have been as good as it is without the eagle-eyed technical editing of Roberta Fineberg and Scott Ghiocel.

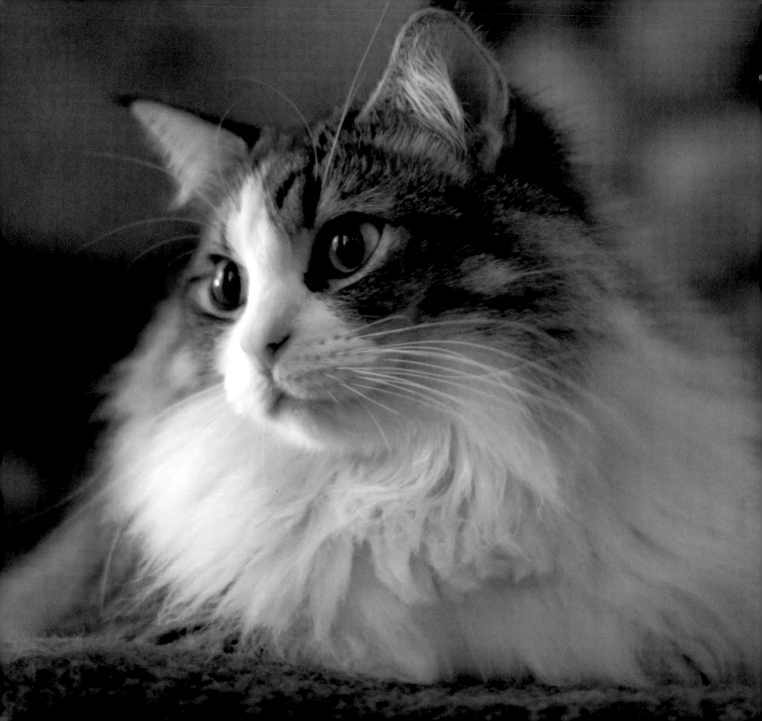

Contents

You don't need professional equipment to get good portraits. The secret behind this shot is simple: lots of natural light spilling through the windows.

Introduction

THE DAY I WAS BORN, my father took one look at me, and walked to the nearest camera shop. He bought his first SLR camera—a Canon A1—and a couple of lenses. I still have that camera, and it serves as my reminder of why photography is so important.

To me, photography is very closely linked with people. Don't get me wrong, I love taking photos of landscapes, and I have been known to take the occasional still life and macro photo in my time. Nonetheless, for me, photography really comes alive when I'm taking photos of people, be it in a formal setting (like studio portraiture or wedding photos), a bit more relaxed (impromptu photo sessions with friends), or even if I'm sneaking around taking photos of complete strangers when I'm abroad somewhere.

People are ever-changing. We are all expressive, creative human beings in one way or another. Capturing the essence of a person can be a challenge, but it is incredibly rewarding to photograph someone and see a particular aspect of his or her personality shine through.

Key points in this chapter

Photographing people is challenging but incredibly rewarding. It doesn't matter if you choose to photograph complete strangers or your very best friends: There is something intrinsically intimate and exciting about photos of people.

In this chapter, we will explore what it means to photograph someone, along with why and how you can get better photos. If you're keen to improve your portraiture right away, turn to the end of the chapter, where I'll share my top six tips for better photos.

It might be hard to believe, but the photos on this page were taken within an hour of each other, all with the same model. A little bit of creativity goes a long way, as long as you keep trying new things!

As an experiment, think about someone you hold dear: a partner, a boyfriend, girlfriend, or a lover. You might decide to photograph him or her in many different ways; a straight-up passport photo would look very different from a photo of him or her as a super-villain, a manga character, or a subject of your affection, for example.

In portraiture, you can take a documentary approach ("this is what they look like"), or you might decide to tell a story. Dig out some old clothes and play dress-up: Ask your models to dress up as pirates, bank managers, porn stars, Roman-era gladiators, or emo-kids on hot pink skateboards. Does that sound ridiculous? Are you laughing? Good. Photography is meant to be fun, and portraiture all the more so.

Let's have some fun, while learning everything you need to know about how to take great pics of people in the process. Grab your camera, and let's get started!

What is portraiture?

So, you've picked up a book on taking photos of people. Perhaps you've had a camera for a while, and you haven't quite been able to get your pictures as good as you dreamed of. Or maybe you've only just bought a camera, and have just figured out which way to hold it. Don't fret, weary traveler; we'll cover all of that in due course.

I don't have to tell you that *portraiture* is "taking photos of people"—that much is

We'll talk more about why later, but for now, remember that the eyes are most important in portraiture: Make sure they are in perfect focus.

straightforward. But what are you actually looking for in a good portrait? To me, the most important element is personality. I don't know about you, but I'm not interested in staring at a vacant, bored face. As a photographer, one of your challenges is to engage with your models and in the process immortalize them. No pressure!

Is the person you're photo-graphing mischievous, sexy, funny, or harder than nails? Capture that mischief, sexiness, hilarity, or hardness. We'll get to how to capture somebody's true personality later on in this book, but before you can go and capture the essence of someone, you have to find out what defining characteristics you want to show. If you know your models quite well, you might be able to guess the key aspects of their personality yourself. If you don't know your models, engage them. You may want to get a "feel" for who they are or how they want to be portrayed; spend time getting to know your subject.

Of course, you might instead decide to do the exact opposite: create a persona for your models, and ask them to act it out. For example, you can make someone who is quite shy look bold or sexy or make someone who is usually quite extroverted and extravagant look like a paper-shuffler at a local government office. People who know the model will find it hilarious: Imagine your class clown as a police officer or the wallflower in your group of friends as a can-can dancer! The possibilities are endless. Remain creative at all times.

Even though there's nobody in the picture, most people who know me would recognize this as a self-portrait. This photo was taken with an iPhone: It goes to show that you don't need a good camera to take great photos.

As an exercise, think about some of your favorite movie stars. It's easy imagining Bruce Willis or Angelina Jolie looking hard toting guns, or Hugh Grant with a mindless-yet-charming smile plastered across his face.

When I first started out in portraiture, I spent a bit of time thinking about which actor my models would look like if they were in a Hollywood film. Check out some of the poses, some of the scenes, and some of the costumes they'd wear—and do your photo shoot as if it's a scene from a film. It may be cheating, but it will get you thinking in the right direction!

How to use this book

Right now, you might be thinking: If a book comes with a user guide, can it be any good? Trust me, you'd be surprised how many people don't finish a book about photography because the first couple of chapters didn't work for them.

I've written this book to be as modular as possible. That means if you're curious about knowing the basics of photography, turn to Chapter 3, "Photography Basics." If you enjoy editing photos you've taken, Chapter 7, "Photo Editing," is your new best friend. In each chapter, look for the little yellow sticky notes. If I'm talking about a concept you may have missed from another chapter, I'll cross-reference it; so when I start talking about *large apertures* and *fast lenses*, I'll include a sticky note to refresh your memory.

Of course, even if you feel you're a world champion photographer, it may be worthwhile having a look at some of the chapters you would otherwise skip. I include tips and advice for all levels of photographers throughout. And even if you don't learn anything new, a refresher can't harm!

Capturing people in their natural setting is known as an environmental portrait. It adds an additional dimension to the photo.

KEEP TRACK OF YOUR LEARNING PROCESS!

Before you do anything else, head over to Flickr.com, set up a user account, and start uploading your best photos. You may not be overly proud of all of your photos right now, but there's something to be said for keeping track of your own photographic progress.

When you're working actively on improving your photos, it's incredible how fast you'll learn and improve your photography output. I'm actually quite embarrassed about some photos I was proud of only a few years ago. I occasionally go through my Flickr account and hang my head in shame.

When reviewing my photos today, I can see what I could have improved in photos that I took only six months ago. It feels great to know that I have developed a sharper eye: it means that I'm a better photographer today than I was yesterday. I'm sure I'll feel the same in six months about photos I take today. It's all part of the process of developing as a photographer. The best thing is that whenever I feel that I'm not getting any better, proof to the contrary is right in front of me.

So, have a look at the table of contents, find something that tickles your fancy, and dive right in.

Why take pictures of people?

Why would you want to take photos of people? Personally, I think people are one of the most versatile subjects you can photograph. They are an emotional subject. If you ask people what they love the most, they will usually say their friends, family, partner, children…. You get the idea.

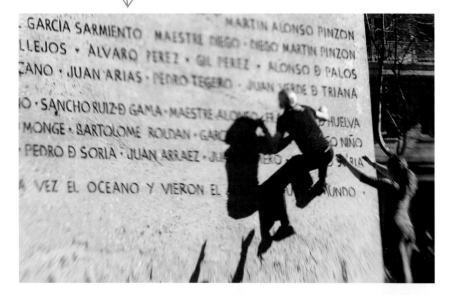

Ingredients: A funky Lensbaby lens and some people exploring a monument.

People are able to do absolutely incredible things: They overcome huge adversities, create beautiful art, and explore the world. The next time you walk past a street performance, take a close look at the performer. Look for incredible feats of human strength, agility, sense of humor, and physical expressions. Turn your camera on the crowd. You'll see myriad expressions: slack-jawed awe, amusement, skepticism, and bemusement—all worthy of photographing.

Photographers have the power to make people look like cruel monsters or bona fide everyday heroes. You can take documentary photos of your kids and see how they are changing, or you can take an artistic approach. Either way, it's all about the people you are photographing and how you're able to capture the essence of their being.

Some cultures believe that being photographed is tantamount to stealing their souls. While I don't think that theory holds much water, I think making the assumption that portraiture is about laying a person's soul bare is an interesting way of approaching photography. It's fiercely difficult, but trust me: You'll know when you succeed,

and your photos will be all the better for it.

This book is designed to show you how to bring your viewers closer to the "souls" of your subjects.

Six steps to taking better portraits

Throughout the years, I've run a lot of workshops and done numerous photo critiques.

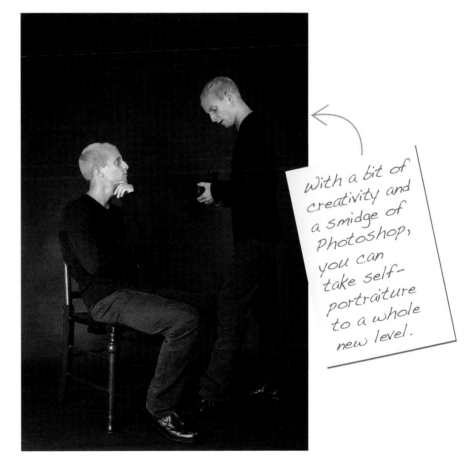

With a bit of creativity and a smidge of Photoshop, you can take self-portraiture to a whole new level.

In doing so, I've noticed that photographers who are just starting out tend to make a lot of the same mistakes: Their portraiture gets caught in a "holding pattern," making it difficult for them to start taking good photos of people until they have solved some basic issues.

So, before you start on anything else in this book, have a look at the following six tips. Learn them by heart, and continue to run through them like a checklist in your head the next time you're taking pictures of people. You don't have to use all of them all the time, but keep them in mind, and you'll see your portraits improve immediately.

1 Get in closer: Whether you're working creatively or documentary style, you'll often find that you want to get in very close. If that's not possible, take advantage of the silly amount of megapixels that come with your camera: Crop the photo in Photoshop (more about that in Chapter 7) to get in closer. It gives a feeling of intimacy, and it means you don't have to worry as much about the background either.

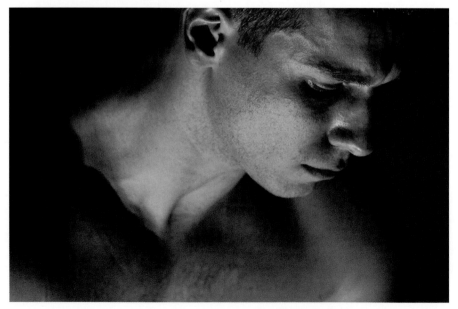

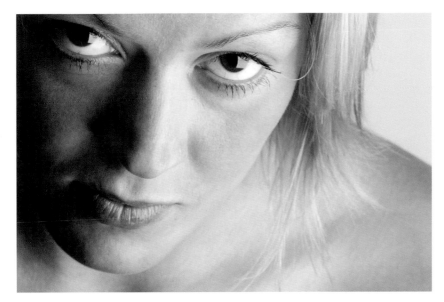

Focus on the eyes: I'll let you in on a secret. The first thing your audience will look at is the eyes of the model. Get them in focus—and I do mean in perfect focus—and you've won half the battle.

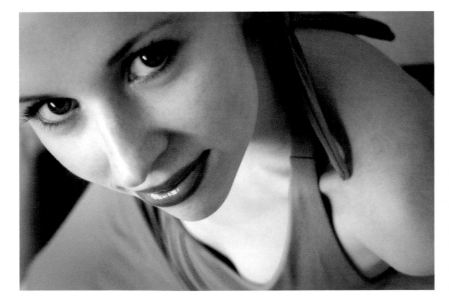

Catchlights: Okay, so I'm breaking Step 2 in this photo (the eyes aren't completely in focus), but see those little reflections on her eyes? Those are *catchlights* and hugely important in making your subjects' eyes seem more alive. You can add them by using a fill flash (see Chapter 4).

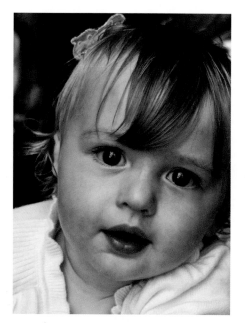

Watch your background: When taking photos of people, your subjects are most important, so ensure that the background doesn't detract from your photo. You can do this by moving your subjects (placing them in front of a smooth white wall instead of a messy bookcase), moving yourself (changing your perspective changes the background), or—in this case—using a wide aperture setting (see Chapter 3) to throw the background out of focus.

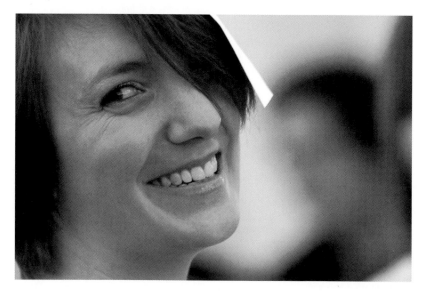

Interact!: Try to engage with your models. Talk with them, give clear instructions, but have a bit of fun with it as well. This photo, for example, was taken at a wedding reception. A quick "Hey! Emily!" and a silly face was enough to make her crack up. 1/80 of a second later, this photo became a reality.

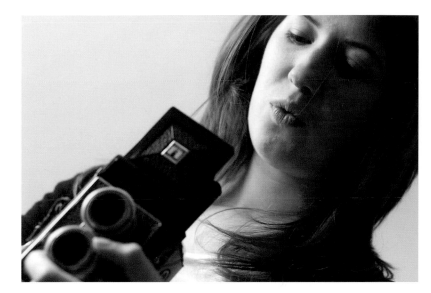

Use the environment: It might sound obvious, but if you're taking photos of a chess player or photographer, get him or her to play chess or take photos. You don't even need to include the props: The concentration and passion will shine through, resulting in great portraits.

Make it happen!

Your assignment is to take a look at your portraiture so far. How many photos break the "rules" in the six tips above? Do the broken rules improve the picture, or would the photos be better if you had followed them?

Now, with the steps freshly in mind, do a photo shoot, where you stick to the rules. You'll see that the photos will come out very differently from your usual portraits.

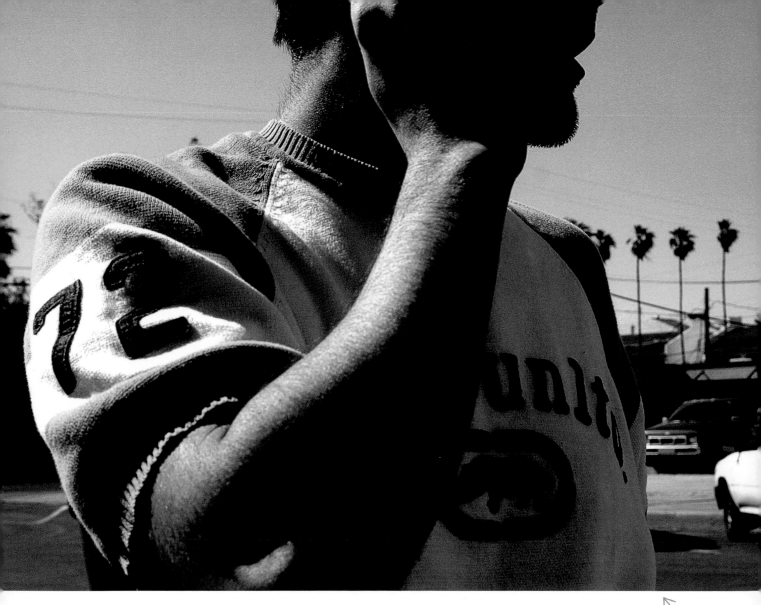

Taken with a Canon EOS D60—you can pick up older dSLR cameras for next to nothing at secondhand shops or on eBay.

Equipment

It ALWAYS AMAZES ME how photographers have a horrible tendency to be complete equipment nuts. The "my camera is better than yours" and the "Canon versus Nikon" discussions rage on the Internet, at pubs, and at the sidelines of sporting events; wherever photographers meet, there'll be a fierce discussion about what's best.

Let me let you in on a secret: On the whole, very few photographers are held back by their cameras, especially when it comes to camera bodies. To prove that point, I made a decision many years ago to only use bottom-of-the-line camera bodies. With very few exceptions, all the photos in this book were taken with affordable equipment. The picture on the cover of the book? It was taken with a Canon EOS Rebel XSi (or 450D if you're in Europe).

The point I'm trying to make is that if you're going to invest money anywhere, invest it in travel and good lenses: Go to places that inspire you, and bring with you some "good glass," as photographers like to call it. If anybody tells you that you need a top-of-the-line camera body with all the most expensive lenses costing more than your car, send them my way, and I'll have a word with 'em. Truly, honestly: If you know what you're doing, you can take awesome photos with just about any camera.

Nonetheless, a book like this wouldn't be complete if I didn't say a few words about equipment that's particularly well suited to portraiture. So here we go…!

Lighting and creativity are more important than equipment!

Choosing a camera body

If you're starting from scratch, the first choice you have to make is which camera body to go for. The great news is that it's very difficult to make a truly poor decision when it comes to buying a digital SLR body. I can't think of a single bad digital SLR camera from the past ten years.

Don't be afraid to buy a second-hand camera if you're on a budget; a lot of people upgrade after a few years, and there are many great bargains to be had.

If you decide to buy new, I would suggest you think about how sturdy you need your camera to be. If you do a lot of traveling and tend to abuse your equipment, then buy a mid-range camera. If you are careful with your equipment, then you're in luck: The entry-level camera probably does everything you need.

I'm not going to get involved in the Canon/Nikon debate. I'm a Canon snapper, but mostly because I bought a Canon D30 many, many years ago.

It was the first affordable digital SLR camera on the market. I already had some fancy EOS lenses from my film days and decided to stick with Canon.

If you don't have any equipment, pick your brand, but be aware that the choice you make will follow you for many years to come, especially if you invest a bit of money in good lenses, too. In general, I tend to recommend you choose either Canon or Nikon because those brands have the most extensive range of lenses and accessories. In practice, all camera manufacturers build some fine cameras, so you can't really go wrong. Buy a camera, and don't look back.

BUYING A SECONDHAND DSLR CAMERA

Test out a secondhand camera before buying. Test all the buttons to see if they work, and then take a few photos with it at different ISO ratings, like ISO 100, 400, and 1600, and then look at the photos in full screen on a computer.

If the photos don't have dust or odd discolorations on them, the camera is probably OK— grab yourself a bargain!

Breaking the "rules" of portraiture is half the fun.

Buying lenses

There are two important things to look at for in a good portrait lens: You'll want something sharp and bright. The "sharp" part means that you need a good quality lens. "Bright" refers to the maximum aperture, such as f/2.8. A consumer-grade lens with an f/5.6 maximum aperture usually won't cut it. As we'll see later in this book, it's useful to be able to shoot at a large aperture, to throw the background out of focus.

Don't let the above put you off, though: You can take portraits with just about any lens. Give it a shot with whatever equipment you already have, and you will probably find that you can get some good results already. If you're ready to take the next step, however, it's worth thinking carefully. Why? Well, you're probably about to spend a lot of money....

There are a lot of different schools of thought about what makes a good portrait lens, and I'll discuss some of them here. One thing I would say right off the bat, however: Do you remember how I said that you could get away with buying a cheap camera body? The same rarely applies to lenses.

If I had used a larger aperture here, such as f/2.8, the background would have been more out of focus. That probably would have been a more pleasing result overall.

On the bright side, if you buy good quality lenses, they will last for a very long time indeed. I have a few lenses that I bought more than ten years ago that are still going strong. Remember that Canon lenses can't be used on Nikon, Sony, or Pentax cameras. This is why it's important to make an informed choice if you make the splash and buy some expensive lenses: If they aren't transferable to your next camera body, you'll have to buy new lenses, too. That quickly gets expensive. The great thing is that if you look after your lenses, they will easily outlast a camera body, so you just buy a new body, and keep using your favorite lenses. I have one particular Canon warhorse that I paid a lot of money for a decade ago. I've used it on eight different Canon camera bodies through the years, but it still gets me the shots I want.

The point I'm trying to make is that when it comes to glass, you have to be a discerning customer. Try the lens you are considering before you buy it, insure it properly against accidental damage and theft, and be extra careful with it.

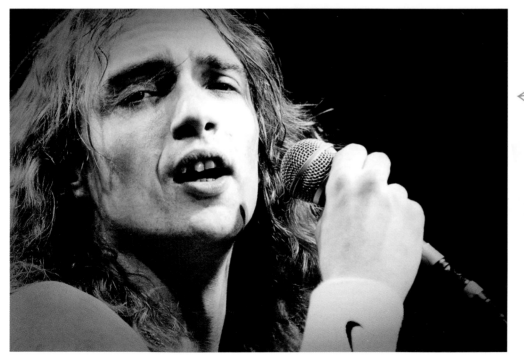

A 70-200mm f/2.8 zoom lens is perfect for action shots and concerts.

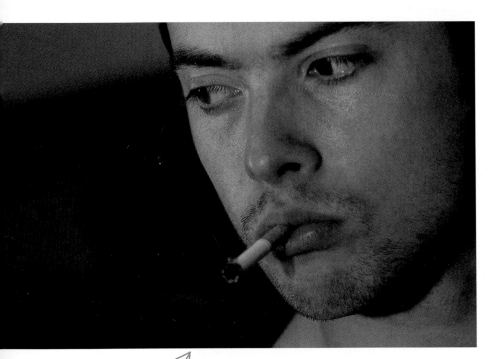

Shooting this photo at f/2.8 gave me a low depth of field. It really helped remove the messy background.

If you have a professional photo store nearby, they might let you borrow a lens for a day to ensure it's the right one for you; but now that many people are buying their lenses via the Internet and the margins in the professional market are shrinking, you may struggle to find anyone willing to let you wander off with a lens.

Luckily, there are a lot of shops and Internet services that let you rent camera lenses by the day, week, or month. Before you potentially plonk down a thousand dollars or more for a good quality lens, it's a good idea to rent one for a while, to make sure it works well for what you are planning to do with it. Of course, it's possible to buy secondhand lenses too, both in stores and via the Internet.

Great lenses for portraiture

While I usually have a strong preference for prime (i.e., nonzoom) lenses for most types of photography, in portraiture it's often quite handy to have a zoom lens. If you're serious about photography, it might be worth investing a bit of money into getting a good all-round lens.

Wide-angle lenses are sometimes usable in portraiture, but the problem is that if you get close enough to someone with a wide-angle lens, the facial features will distort. Most significantly, if you take a close-up portrait of someone with a something like a 20mm lens, you'll find that his

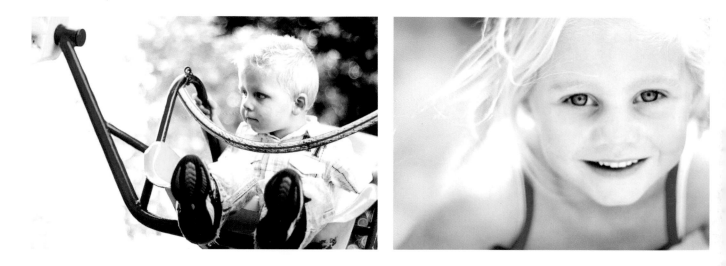

Some people like the effect of soft-focus lenses, but these days it's less hassle and much cheaper to achieve a similar effect in Photoshop.

or her nose will look enormous. This isn't usually very flattering, though you might decide to use it as a creative effect.

So, if wide angles are usable only as an exception, what *does* work well? The opposite, of course! A lot of photographers swear by portrait lenses in the region of 85–135mm. Canon for a long time made a specialist portraiture lens: the Canon EF 135mm f/2.8 with Softfocus. The Softfocus effect isn't everybody's cup of tea, but it's a lovely portrait lens nonetheless.

A great all-rounder is a 70–200mm f/2.8 lens. Canon and Nikon make their own versions of this lens, but they are very expensive indeed. It's worth the money if you are working professionally, but don't despair: If you're looking to save some money, have a look at Sigma's range of lenses. Sigma makes its optics to fit most current cameras, and its high-end offerings are mighty fine indeed. While the quality isn't quite as uncompromising as the top-end glass made by the camera manufacturers

themselves, the lenses are about 60% cheaper, and are great value for money.

Personally, I swear by my Sigma 70–200mm f/2.8 APO EX HSM lens: I've used it for portraiture, concerts, sports, and wildlife photography with great results.

If you fancy getting a bit more specialized, most camera manufacturers make a 100mm f/2.8 macro lens, which is absolutely fantastic for macro photography, obviously, but also great as a portrait lens.

Flashes and lighting

As you're starting to get the hang of portraiture, you will soon start feeling restrained by the lighting situations that are available to you. Don't get me wrong: Natural lighting often looks fantastic, but sometimes, you just want more. And that's where artificial lighting and strobes come in.

Artificial lighting comes in two flavors: flashes and continuous light. For portraiture both give great results, but they both have their own advantages and disadvantages.

Flash tends to output more light than continuous light, but it can be difficult to get the effects you want without quite a bit of practice. If you decide to go down the flash route, you can

For more on creative flash techniques, check out Chapter 5, "Getting Creative."

Flash allows you to take full control of the light in a scene— with awesome effects.

For a simple introduction to off-camera flash photography, check out this little video on YouTube: tinyurl.com/strobist101.

choose between using smaller, battery-powered strobes that you can use either in the camera's hot-shoe or off-camera with a remote trigger. The other option is to use studio strobes; these are usually mains powered and more powerful, but significantly bigger and less portable.

Continuous light can be easier to work with than flash, because you can see immediately what the lighting scene looks like. The downside of continuous lighting is that it's much less bright than flash photography.

I could easily fill a whole book on the ins and outs of creative lighting, but that's a little beyond the scope of *this* book. For now, I would recommend you buy at least one on-camera flash, as it will come in handy no matter which direction you decide to go with your photography in the future.

On-camera flashes need to charge from a set of batteries before you can take a photo. When your batteries run low, the charge time increases, especially if you're using your flashes at full power output. You can minimize the effect by using rechargeable batteries (they are better at powering high-drain devices than alkaline batteries), or by using an external battery pack for your flashes.

DO-IT-YOURSELF CONTINUOUS LIGHTING

If you want a taste for working with artificial lighting without investing too much money, use halogen *shop lights* or *work lamps*. You can buy these cheaply from hardware shops (often complete with stands), and they put out a lot of light.

The downside of these lights is that they are not color balanced, so your results may vary throughout a shoot— although if you are shooting in RAW format, you can fix this problem easily later on. Another downside is they get very warm, so any models in front of the lamps can quickly get uncomfortable.

Combining flash with colored bits of plastic known as gels can give eye-catching effects. In this photo, I used two flashes: a white one to light the label on the gin bottle and one with a blue gel for the background.

Reflectors and diffusers

Whether you're working with natural or artificial light, it is often beneficial to manipulate the light in one way or another. Two of the easiest ways of doing this is by using reflectors and diffusers.

Unsurprisingly, a reflector is designed to reflect light back at your subject. This can be great if you're outside taking photos in the sunshine, when one side of your model might be very bright due to the sun, while the other side is plunged in shade. A reflector—normally a silver-colored material stretched over a collapsible hoop—can be used to *bounce* the sunlight back onto the dark side of your model's face. It sounds really low-tech, but trust me, it works really well!

You can also get gold-colored reflectors; they work the same way but help "warm" the light at the same time, which is great if you're taking photos in the shade, for example.

A diffuser is usually a very fine-woven white fabric. You can use diffusers as reflectors, but they usually reflect less light than purpose-made reflectors. Instead,

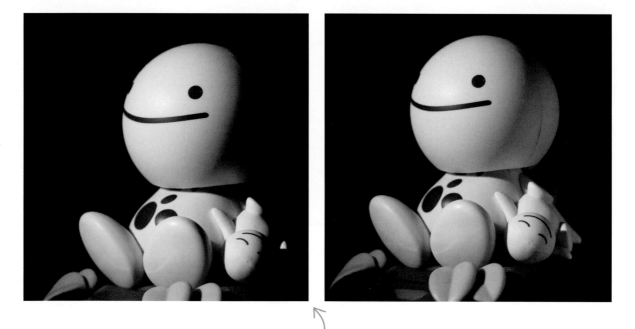

Adding a reflector to the right of this figurine shows what a big difference it can make, even to a simple photo like this.

the idea is that you let your light source shine through the diffuser. The result of this is that the light source appears to come from a bigger area, which gives softer light. It can often be a bit difficult to understand why diffusers work so well, but if you've ever been out taking photos on a sunny day and a cloud went in front of the sun, you've experienced a huge diffuser in action. After all, white clouds don't block out the sun completely; instead, they reflect the sunlight so it comes from a much bigger area, just like a diffuser.

When you start doing studio work, you'll find that diffusers and reflectors are completely indispensable, but even if you're going down the natural-light route for a photo shoot, it's worth considering whether some extra toys are in order to get the photos you want.

Both diffusers and reflectors come in different sizes: from tiny, coffee-saucer-sized ones used for macro photography to huge, full-body-sized ones used for outdoor fashion photography. Be careful which one you buy!

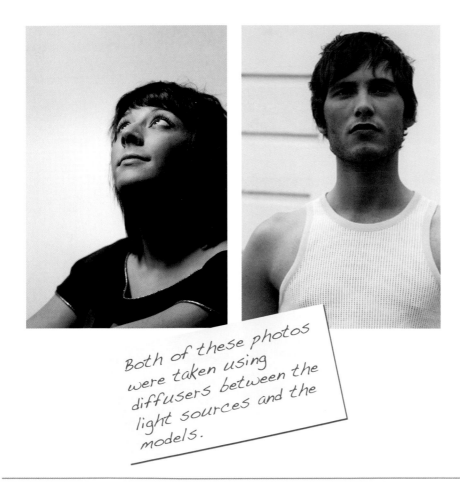

Both of these photos were taken using diffusers between the light sources and the models.

MAKE 'EM YOURSELF...

The great thing about light-modifying equipment is that you don't want it in your photos anyway, so it doesn't have to be pretty or high-tech.

Get a large, flat piece of white Styrofoam: tah-daa! It's a perfect, soft reflector. If you want to reflect more light, cover it in crinkled aluminum foil.

For a diffuser, you can use nearly any semitranslucent material: A bedsheet does the trick. If you want less light coming through (or a more diffused light), simply fold it in half.

Outfitting a simple portrait studio

For the longest time, I was strictly a natural-light photographer. I always had a flashgun or two tucked away, but I have to admit that I never really figured out how to get the best effects. Then, a few years ago, I decided it was ridiculous that I didn't use artificial light more often, and I went the whole hog, with a full kit. I haven't looked back. Artificial lighting doesn't have to look "fake," and it gives you a tremendous amount

Strong side-lighting can help moody self portraits. Give it a shot, it is surprisingly easy.

of flexibility when it comes to getting the mood you want in your photos.

Building a simple studio yourself doesn't have to be prohibitively expensive either. You can buy complete studio kits for under $300 these days. It may not be the best or the sturdiest equipment money can buy, but even the cheapest flash systems will give better results than shooting with natural light only.

At the bare minimum, you'll need two lights (three are better). Whether you choose flashes or continuous light is up to you, but I'd probably choose the former, just because of the extra light output. In addition to the lights themselves, you need stands so you can raise and lower the lights to the optimum position.

To shape the lights, you'll need some light modifiers: reflectors are handy, and a softbox (basically a big diffuser) will help make the light look nice and soft—perfect for portraiture.

Unless you prefer to do location shots, you're going to need some backgrounds as well. Backdrops normally come on rolls of paper or fabric that you hang from two pieces of metal known as *stands*. A stand is a sturdy, tall stick that holds the roll of backdrop up behind your models. If you are building a permanent studio, you can also consider a wall-mounted backdrop holder. It does the same thing, but is less likely to fall over, and keeps your rolls of backdrops out of the way when you're not using them.

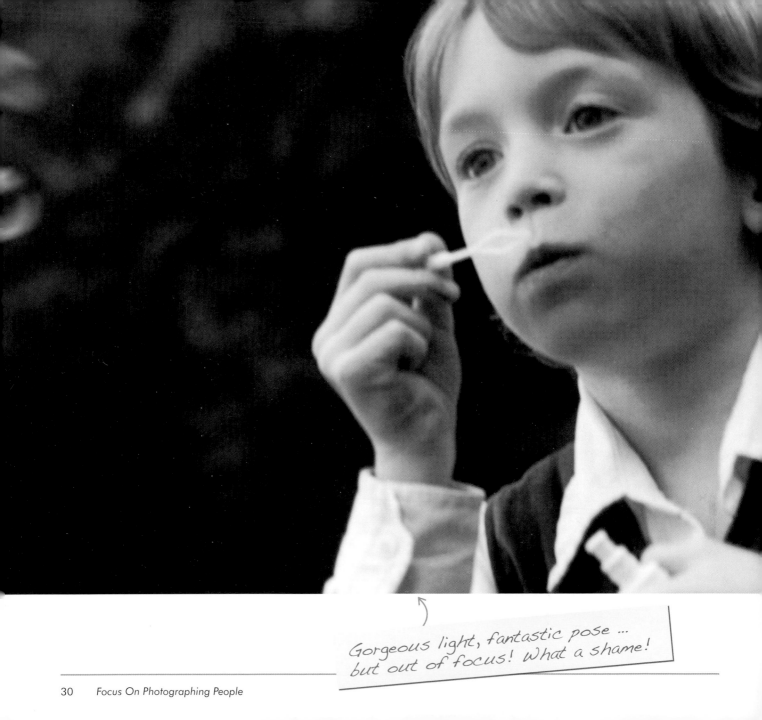

Gorgeous light, fantastic pose ... but out of focus! What a shame!

Photography Basics

LIKE ANY ART FORM, there are two sides to photography. You need to have artistic ideas—often referred to as a *photographer's vision* or the *photographer's eye*. The flipside of that coin is the technical skills you need in order to get photos to look the way you want them to.

There is no point in taking photos that are technically perfect but incredibly boring. Similarly, it doesn't help if you can compose the most fantastic photographs in your mind's eye but you can't translate this mental image into a physical one by adjusting the settings on your camera.

In this chapter, we sidestep the creative side of photography and take a closer look at the technical skills involved, including how ISO, aperture, and shutter speed work.

A high ISO can work in some photos, but if you push it too far, you'll often find you get too much digital noise. In this case, ISO 1000 was a bit too much for my liking.

What affects an exposure?

Put extremely simply, a camera is a lightproof box. In the past, the box contained film, but these days, we're mostly working with digital cameras. In a digital camera, you'll find an imaging chip. This imaging chip has one simple task: to measure any light that hits it. When you take a photograph, thousands and thousands of tiny little light meters measure how much light has gone through your lens, into the camera body.

When you are taking photos, all you are doing is adjusting how much light actually goes into the camera body. You do that by adjusting three settings on your camera: the shutter speed, the aperture, and the ISO.

Imagine for a second that your camera body is a bucket, and you have been asked to fill this bucket. You have three different water hoses available to you: one the size of a straw, one the size of a cigar, and one the size of a drain pipe. Needless to say, you will be able to fill the bucket with water with any of the three hoses—the difference is how long it takes.

No part of this photo is too bright or too dark, and there is plenty of detailed definition in the gray area between deep black and brilliant white. Perfect exposure, then!

Photographers often speak about *fast* and *slow* in ways that can be a little confusing. I'm trying to be consistent in this book, but the following list might come in handy.

- A fast *shutter speed* is a shutter that is open only for a brief period of time (i.e., lets through less light).

- A fast *lens* is a lens with a large maximum aperture (i.e., lets through more light).

- Fast *film* (or, more commonly, a fast ISO on a digital camera) is a higher ISO rating—like ISO 1000 instead of ISO 200.

- People rarely speak about a fast *aperture*, but if they do, they refer to a large aperture (i.e., lets through more light).

Funky effect courtesy of a Lensbaby lens. Perfect exposure, too!

Photography is similar. Inside your lens is a diaphragm, which is basically a device that can change the size of a hole. As you would imagine, a big hole lets a lot of light through, and a small hole lets less light through. This hole is known as an *aperture*. Selecting a large aperture is like choosing to use the biggest water pipe to fill the bucket. Choosing a small aperture does the opposite.

The other control we spoke about is your shutter speed. This is the amount of time your camera lets light through the shutters inside your camera. A *fast* shutter speed might be just 1/1000 of a second—this doesn't let through a lot of light. A slower shutter speed could be 1/50 of a second. A 1/50-second shutter speed means that the shutter is open 20 times longer than a 1/1000-second shutter speed. You may have guessed it: that also means it lets through 20 times more light.

Finally, we can control our exposure by adjusting the ISO value on your camera; we'll talk about that in more detail later in this chapter.

Overriding the camera's decisions: Manual mode

Exposure is often the first stumbling block for new photographers. Of course, there are techniques you can use where you are using a "wrong" exposure on purpose, but that can be extremely tricky to get right. If you're just starting out, it might be a good idea to aim to get your exposures "right." Once you can consistently create correctly exposed images, then you can throw all caution to the wind and experiment to your heart's content!

There is some good news in all of this, however: The light sensor in

In this photo, the model's face is so bright that you can't even see her skin anymore. That means I overexposed it by accident.

Overexposure doesn't always have to be a bad thing. In this photo, I decided to go for a stark contrast, and the large "blown-out" areas look pretty good.

This image contains a lot of black, but because the bright bits look so good, the overall effect is stunning.

Your camera tends to get the exposure right, but there are situations where the light meter gets consistently confused. If you're taking photos in snow, for example, the camera might try to expose the snow correctly, which leaves what you are trying to photograph way too dark. The opposite happens sometimes when you're taking photos with large dark backgrounds.

To convince your camera that it's wrong and that you're right, you can change the EV (Exposure Value) adjustment. Check your camera manual to learn how to do it—dial in a negative value if your pictures are coming out too bright, and a positive value if they're too dark.

Your camera still does all the thinking, but will adjust its exposure with the amount you've dialed in.

modern cameras is an impressive piece of technology, and you'll rarely find that your camera gets it wrong. If it does, you have a few options: Use EV adjustment (see the sidebar "When you know better than your camera"), or use Manual Exposure mode to wrench all control from your camera.

Moving away from automatic camera modes

You've probably seen the mode wheel on top of your camera: It's the one that shows "P" (for Program mode), "T" or "Tv" (for Time mode—or Shutter Time Priority), "A" or "Av" (for Aperture Priority), and "M" (for Manual). Many cameras also have a series of *creative* modes, such as for night-time photography, portrait photography, landscape photography, and so on.

Since we're aspiring to be "proper" photographers, it's time to ditch the automatic modes for good—no more automatic modes! By the time you've read this chapter, you'll know everything you need to know, and you'll never need to cheat again. If you ask me, that's the first step toward becoming a real photographer!

To take your first step away from the automatic modes, but if you still want the camera to do the heavy lifting for you, choose P (for Program mode). In this mode the camera will select the aperture and shutter time for you, but you can turn a wheel on the camera to adjust the bias of an exposure. To do this, half-press your shutter button. This will cause the camera to measure the light and calculate an exposure.

These days, I rarely use anything other than Aperture Priority or Manual Exposure modes.

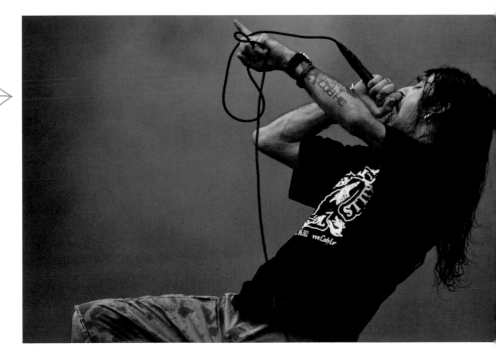

Program mode can give some fantastic pictures—just point and shoot!

Check your camera manual for how you change the bias of an exposure when you're in Program mode. On most cameras, you'll have an adjustment wheel near your index finger: turn it one way and it will give you a bigger aperture and a faster shutter speed; turn it the other way, and

BIAS

Shutter speeds and apertures come in pairs. For a given scene, 1/200 of a second and f/8 may be the perfect combination of shutter speed and aperture. However, you can increase the shutter speed (to, say, 1/800 of a second), if you also select a larger aperture (in this case, since we quadrupled the speed of our exposure, we would have to use f/4.0).

When you make this change, the amount of light that hits the sensor inside your camera stays the same—but you are changing the *bias* of the photo. This comes in useful if you want to use a small (or large) aperture or a fast (or slow) shutter speed for creative effect or to create a particular photo.

it'll select a smaller aperture and slower shutter speed. Your exposure will still come out "correct" according to the camera, but at least you can influence what the camera is doing.

AUTOMATIC OR PROGRAM MODE?

In Automatic mode, you're using your SLR camera as a very expensive point-and-shoot camera. Great for quick snaps, but it means you let the camera do all the work, and you don't get the creative influence you want.

Start shooting in Program mode instead. The camera still chooses your aperture and shutter time for you, but you can select the ISO and you can override the camera's decisions by choosing an EV bias (i.e., to trick the camera into over- or underexposing your images).

Better still, try to start thinking about what you want to achieve with your images, and use T (Shutter Priority), A (Aperture Priority) or even M (Manual mode), instead of Automatic or Program mode!

To get this photo,
I exposed for
the background
on purpose, by
dialing in a negative
EV compensation
of -1.5.

Shot in Aperture
Priority mode,
because I knew I
wanted to use a
large aperture—in
this case, f/2.8.

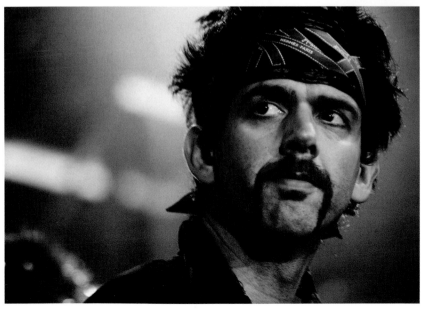

Shutter and aperture priority

A little later in this chapter, we look at how aperture and shutter speed affect your photography.

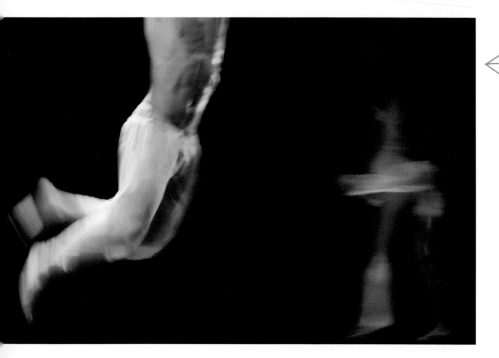

To give a feeling of speed, I shot this photo with a relatively slow, 1/25 of a second, shutter speed.

Put simply, a photo taken with a slow shutter speed will look very different from a photo with a fast shutter speed. Similarly, a photo taken with a large aperture will look significantly different from one taken with a small aperture. We also talk about the creative effects of large and small depth of field later in this chapter.

Once you know what the effects of the various shutter speeds and apertures are, you'll find that you'll want to take advantage of these differences when you're taking photos of people.

In Aperture Priority (A or Av on your mode dial) mode, you select the aperture you'd like to use, and the camera uses its light meter to calculate what the appropriate shutter time is, given the lighting situation. You would use Aperture Priority mode either to dial in the creative effects you want to achieve (for portraiture, a large aperture for shallow depth of field is the most common effect you might want to aim for), or when you simply want to ensure that you have the fastest shutter speed available at any given time. To ensure your camera always uses the fastest shutter speed possible, you simply choose the biggest aperture for your lens— your camera will then match this with the fastest shutter speed.

Unsurprisingly, Shutter Priority (S, T, or Tv) mode does the opposite: You choose the shutter

time, and your camera measures the available light and selects the aperture for you. You would use Shutter Priority when you want a specific effect that can

UNDERSTAND YOUR LIMITS!

In both Aperture and Shutter Priority modes, bear in mind that if you select a very large aperture when you're outside in bright sunlight, the "correct" exposure might be an extremely fast shutter speed, faster than your camera body might be able to do. If this happens, your camera will over expose the image. It will choose the fastest shutter speed it can, but if that isn't enough, you're out of luck.

The same happens with Shutter Priority mode: you can choose 1/1000 second exposures all you like, but if you're indoors and your lens only supports f/3.5 as its largest aperture, it may well be that your photos come out too dark.

When these two situations occur, you won't get correctly exposed photos. Your camera will try to warn you of what is going on: The aperture or shutter speed readout in your viewfinder blinks.

be achieved by using a slow or fast shutter speed. If you want to convey a feeling of speed, you might use a slow shutter speed, such as 1/20 of a second (because this causes some motion blur). To freeze motion, you may choose to use a fast shutter speed, like 1/1000 of a second or faster.

In both Aperture and Shutter Priority modes, you can still increase or decrease the exposure by changing the EV setting—just like in Program mode.

Focusing properly

As we discussed in the Chapter 1, if you manage to get the eyes in focus, you've won half the battle. In some cases, of course, that's easier said than done.

Many photography books will tell you to use manual focus,

but personally, I think that's hogwash. The autofocus on most modern SLR cameras is faster and more accurate than the manual focusing skills of every single professional photographer I know.

If you've ever been frustrated by the focusing on your camera, the good news is there are a few

If the eyes are in focus, you've got the focus right!

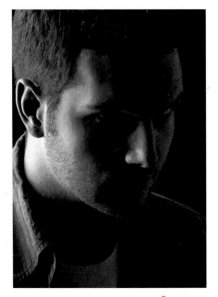

Even if you're going the moody route and don't really show your subject's eyes, that's still the part of the photo people will look at first, so get them in focus as much as possible.

If you've ever used an old-fashioned SLR with manual focusing, you were probably quite successful in getting the focus right. That's because old SLRs used to have a special *focusing screen* inside the pentaprism on top of the camera (the bit you look into). This focusing screen would make it a lot easier to focus, but it would also make the viewfinder much darker.

Modern cameras have sacrificed ease of focusing for a brighter viewfinder. A good choice, I think, but the result is that you will, in most cases, probably have to start trusting your autofocus.

tricks you can use. Autofocus works best if you aim your camera at something that's full of contrast and well lit. Point your camera at somebody's T-shirt, and there's a good chance that you'll find the autofocus "hunting," that is, going back and forth trying to focus. Help it along by aiming your camera at the edge of the neck and the T-shirt instead, and autofocus will work in a fraction of a second.

The correct way to focus is as follows. If you are using a zoom lens, zoom all the way in. Aim your camera lens square at your subject's eye, and press the shutter button halfway. This will cause your camera to autofocus and do a light reading. Now, while keeping the button half-pressed, zoom back out, compose your photo, and then press the button the whole way.

It might take a little bit of time to get used to the half-pressing-the-shutter-button technique: You might find that you take a few photos without meaning to, or that you accidentally let go of the button. Don't give up; this is how the pros do it, so you may as well get used to it. Trust me, once you get it down pat, your photos will start coming out much, much better.

Shutter speed

Put simply, shutter speed is the amount of time the shutter in your camera is open when you take a photograph. A *fast* shutter

A fast shutter speed helps freeze motion, which helped me capture the passion in this concert photo.

A slow shutter speed can give a feeling of movement, like in this photo of a belly dancer in action.

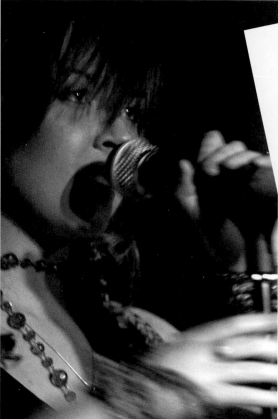

A slow shutter speed makes her hand look slightly blurry, and the photo becomes more dynamic.

suggest that you might need a shutter speed of around 1/2000 to do the former, and around 1/60 or so to do the latter, but the only way to know for sure is to experiment.

If you're most interested in shutter speeds to get the effect you're aiming for, it might be a good idea to use the Shutter Priority mode on your camera. Select the shutter speed you desire, and let the camera select the corresponding aperture. If you find that your shutter speed is too fast for the maximum aperture of your camera, you may have to adjust to a higher ISO—400–1600, for example; more about that later in this chapter.

Aperture explained

Aperture is the second major control when you're out and about taking photos. *Aperture* comes from a Latin word meaning "opening" or "gap"— and that's pretty much all it is. Inside your camera lens is a device called a *diaphragm*. This is simply a series of plastic or metal bits that interlock in such a way that they can move to create a variable-sized hole.

speed means that the shutter is open for a short period of time, while a *slow* shutter speed means that the shutter is open for longer.

There are no hard-and-fast rules about what makes a fast or a slow shutter speed; it all depends on the circumstances. When photographing a cyclist at full speed, you have two choices: You may have to use a faster shutter speed to *freeze* the motion, or you might decide to use a slightly longer shutter speed to give a feeling of movement. I would

Three different apertures,
three completely different
images. Use a large aperture
to blur the background in
your portraits.

Buy a nifty fifty

I mention this several times throughout this book, but it's an important point: Buy a prime lens. Seriously, you won't regret it. A 50mm f/1.8 lens is a lot cheaper than you'd expect, is available for most cameras, and is great fun.

The large aperture is perfect for portraiture and low-light photography, and it is a lightweight lens that is perfect for traveling with.

A shallow depth of field can help the viewer focus on what's important.

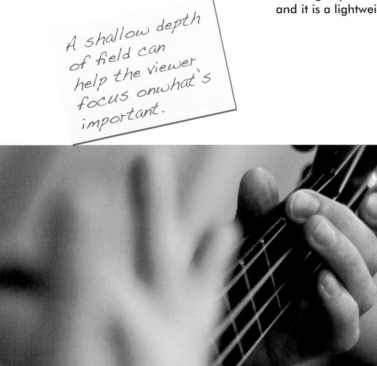

A large aperture, say f/2.8, lets in a lot of light; a small aperture, such as f/8.0 and smaller, will (unsurprisingly) let through less light. This is something you can use to help you. If you are taking photos in bright sunlight, you can use a smaller aperture—f/5.6 is a great baseline—to reduce the amount of light it has to deal with. As you know after reading the previous section, reducing the amount of light means that you can use a slower shutter speed—perfect to get a feeling of speed in your action shots.

As you may have guessed, the opposite is also true. If you use a larger aperture, you let more light into your camera, and you can use faster shutter speeds. If you are already at the biggest aperture your lens can muster, then your only option is to swap to a different lens.

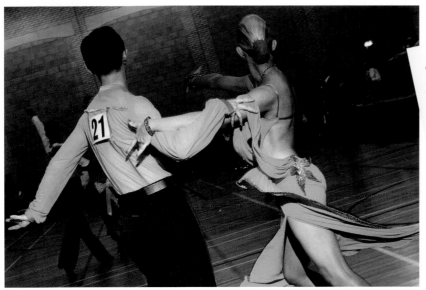

Using a large aperture helps blur the background in this shot, so you can focus on the dancers, rather than on the messy gym.

Aperture and creative effects

You'll remember that shutter speed has two effects. A fast shutter speed lets less light into the camera but also helps freeze motion. A slow shutter speed (60 and below) lets in more light but can be used for creative motion blur effects.

Aperture, like shutter speed, has other effects on your pictures beyond just letting less or more light onto your imaging sensor. Aperture affects how big your picture's depth of field is.

"Depth of *what?*" you say. Don't worry, it's a lot less complicated than it sounds. It's easiest to explain with a photograph though; have a look at the photos on page 48. As you can see, some parts of this photo are sharply in focus, while others aren't. If only a small sliver of the photo is in focus, we say that a picture has a *shallow depth of focus*. If all (or most) of the photograph is in focus, it has a *deep depth of focus*.

You can dial in the depth of focus by adjusting your aperture: A large aperture (such as f/2.8) gives a shallower depth of field than a smaller aperture (such as f/8). In portraiture, you can use this effect to isolate your subjects from the background, especially when you are taking photos in busy places, like out on the street.

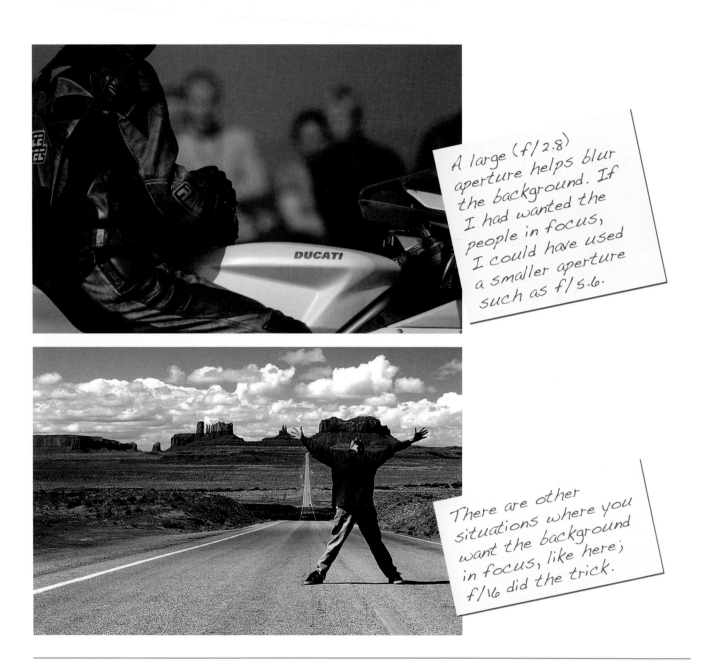

A large (f/2.8) aperture helps blur the background. If I had wanted the people in focus, I could have used a smaller aperture such as f/5.6.

There are other situations where you want the background in focus, like here; f/16 did the trick.

How ISO works

We're starting to understand shutter speed and apertures, but there's one more variable in the big equation that is a perfect exposure: ISO.

Your shutter speed is the amount of time your shutter is open. Your aperture regulates how big the hole inside your lens is. Both of these settings physically restrict how much light reaches the imaging sensor. ISO is slightly different, in that it adjusts the sensitivity of the sensor: An exposure of 1/60 of a second at f/4.0 is the same physically no matter what ISO you set your camera to.

The difference is that as you go up the ISO scale, your camera *multiplies* the amount of light it has measured by the ISO. So, a scene photographed at ISO 400 will come out twice as bright as the same scene with the camera set to ISO 200. ISO 800 is twice as bright as ISO 400, and ISO 1600 is twice as bright as that again.

ISO has a downside, too, of course: At higher ISOs, you'll start seeing a lot of *digital* noise in your images, and they will start looking a little fuzzy.

In badly lit venues, shooting in high ISO can be a life-saver—ISO 1600 in this case.

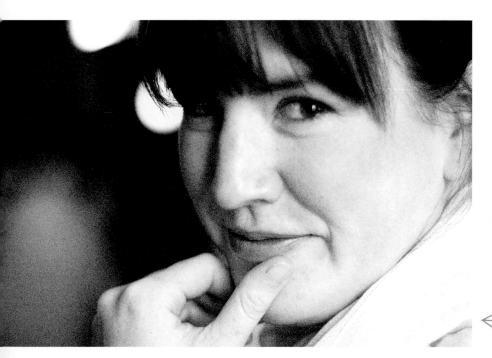

With newer dSLR cameras, don't be afraid of shooting in high ISO—the noise can in some circumstances actually add to the photo. This one, for example, was shot at an incredible ISO 12,800.

ISO AND FILM SPEEDS

Back in the days of film, you would choose which *film speed* you wanted. The difference was that ISO 400 film was a lot more sensitive than ISO 100 film; so if you knew you were going to take photos in low light, you could help your camera along by loading the appropriate film.

Obviously, your digital SLR doesn't accept film, but it still has an ISO setting, which is equivalent to changing the film in an old-fashioned camera. The good news is that you don't have to wait until the end of the roll before you change. If you want to, you can switch ISO between every single photograph.

Pros and cons of using ISO

There is a downside with shooting at a higher ISO: Your pictures are significantly more affected by digital noise. For some scenes, this may not matter all that much, but you'll often find that you lose some degree of color definition and sharpness.

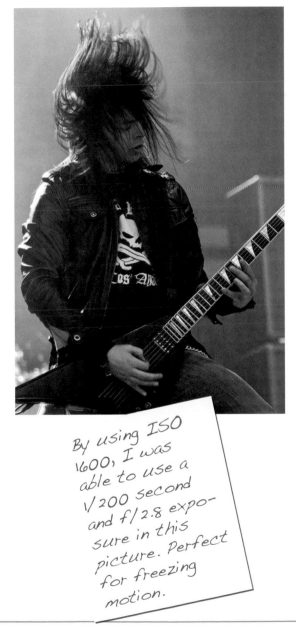

This is from a nude photo shoot I did. At first, I couldn't quite get the picture to have the impact I wanted, but by using a very large aperture (f/1.4) and a high ISO rating (ISO 1600), I was able to add the mystique the photo needed.

By using ISO 1600, I was able to use a 1/200 second and f/2.8 exposure in this picture. Perfect for freezing motion.

Personally, I don't mind so much, but it means that high-ISO pictures tend to look better in black and white than in color.

As a general rule, try to stick to the lowest ISO you can. In practice, that means if you are shooting at ISO 400, f/4, and a 1/1000 second shutter speed, you can consider taking the photo at ISO 100, f/4, and a 1/250 second shutter speed instead.

Shutter, aperture, and ISO: Putting it all together

As you've probably gathered by now, there is no real right and wrong when it comes to getting the right exposure. The challenge is

An exercise in happy mediums: f/2.5, 1/200 second, and ISO 200 made a photo that works well overall.

to find the right balance between shutter speed, aperture, and ISO.

The *right balance* is a fine line between the technical considerations (how much light do I need to get the right exposure?) and creative concerns about motion blur versus freezing motion, shallow versus deep depth of field, and little or a lot of digital noise.

It is worth noting that throughout this book I'm often using extremes to make a point—I'll include photos taken either at f/1.4 or at f/16 to illustrate the difference between an extremely shallow or a very deep depth of field—but in real life, you'll be choosing whatever you feel works best for what you are trying to achieve.

Picking the right lens

A lot has been said about what is the "right" lens for portraiture. Some swear by a 50mm, others say that a 100mm is the best choice. I even know some photographers who prefer shooting portraits with a wide-angle.

The human eye has a field of vision that is similar to a 50mm lens, and

portraits taken around that focal length tend to look quite natural. One top tip, however, is that people tend to look better when seen through a longer lens. Try it yourself: Break out your telephoto lens, take a few steps back, and

take a photo of one of your friends. Compare that to a photo taken with a wide-angle lens, and see which one you prefer!

In addition to being more flattering, another advantage

of telephoto lenses is that when you shoot wide open, you get a more limited depth of field and are able to throw the background out of focus nicely.

Remember that photographing people is as much about interacting with your models as it is about technique and equipment.

Having said all that (and because I'm sure you're wondering), my lens of choice for portraiture these days is a Canon 50mm f/1.4, with my Sigma 70–200mm f/2.8 coming in a close second.

Shooting with a long focal length (200mm in this case) is often more flattering than with a wide-angle lens.

White balance

I could write a whole book on white balance, spending pages upon pages on the technical details of how to white balance your photos as perfectly as possible; how to balance natural light with artificial light; and how color temperature relates to the various color spectra, and so on.

You'll be immensely relieved to know that I'm not going to ramble on about it for too long, however. For purposes of portraiture, there is one incredibly quick way of getting

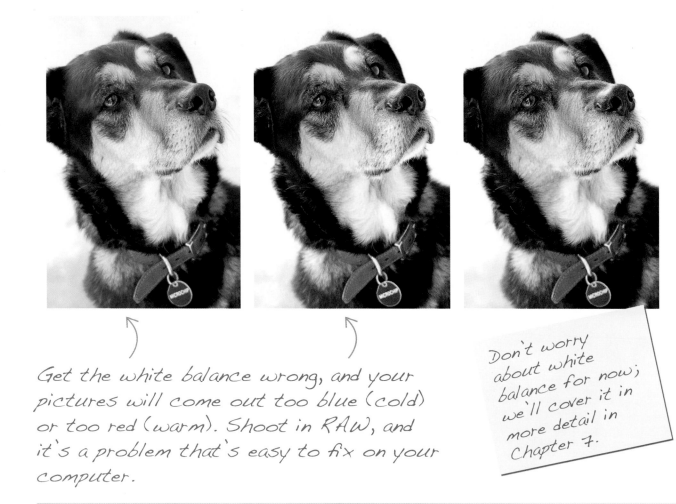

Get the white balance wrong, and your pictures will come out too blue (cold) or too red (warm). Shoot in RAW, and it's a problem that's easy to fix on your computer.

Don't worry about white balance for now; we'll cover it in more detail in Chapter 7.

it right: Shoot in RAW. When you set your camera to save RAW files (as opposed to, say, JPGs or TIFF files), it stores all the information it has captured. This means that you can worry about white balance when you're back at your computer at home: nine times out of ten, that's the easiest way to get your white balance right.

If you want to help yourself along, ensure that you carry a *neutral gray* card with you—purchased for a few dollars in all good photography shops. Take a picture of the card whenever the lighting situation changes, and you'll be able to use this photo as a reference when the time comes to edit the photos. In practice, this means that you spend a bit of time experimenting with this photo, and then simply replicating the settings on the rest of your photos in post-production—it saves you a ton of time.

When used creatively, you can make your portraits seem more approachable by using a slightly warm color balance.

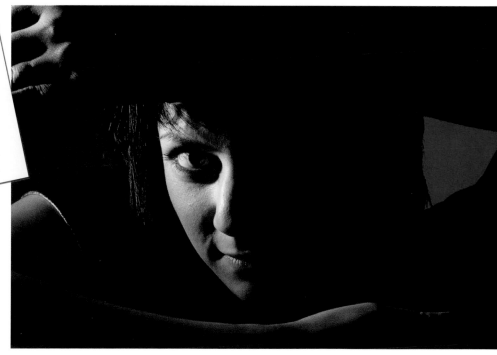

Shooting in RAW

I've mentioned it a couple of times already, but a good thing cannot be repeated often enough. Grab your camera right now, go into the settings, change the file format to RAW, and don't change it back.

To understand why, we have to take a look at how your camera works. When it takes a picture, it has collected a whole lot of raw data. Every single one of the individual little sensors inside your camera (if you've got a 14 megapixel camera, there are

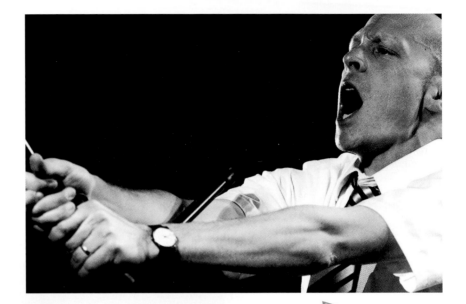

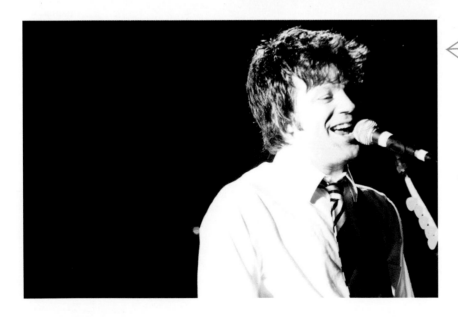

Shooting in RAW is an especially good idea if you're taking photos in complicated lighting situations, like in this Presidents of the USA gig.

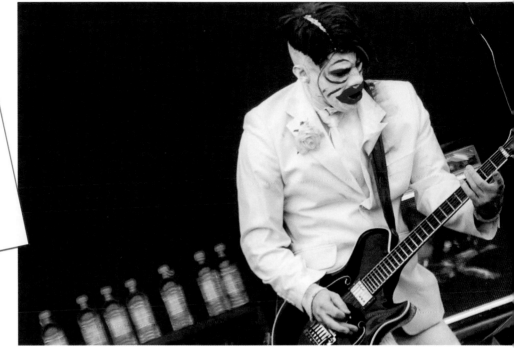

If I hadn't shot this Limp Bizkit gig in RAW, I doubt I'd have had a single usable photo.

14 million individual little light meters on your imaging chip!) has made a measurement.

What happens next depends on your camera settings. If you have your camera set to JPG, it will write all this information to a single, 8 bit JPG file. The problem with this is that your camera has to make a series of decisions in order to do this. Sharpness, color saturation, and white balance are calculated and written to the file, but when this happens, you are in effect losing a lot of information. If your camera gets it right, that's not a problem, but what if you later decide that you wanted to use less sharpness, a different color saturation, or a different white balance? Suddenly, you're out of luck: The data that was originally available has been discarded, and all you are left with is what was written to the JPG file.

In contrast, a RAW file usually has a lot more color information (12 or 14 bit), and contains all the information the camera originally recorded. This means that when you get back to your computer, you get a lot more information you can manipulate—always a good thing.

Composition and Making People Look Good

So far, we've spoken a lot about the basics of photography, but we haven't really looked at any of the really important stuff. Let's face it: The reason why you bought this book is that you want to take stunning portraits of people. Well, you're in luck, this is where the fun begins....

Photographing people is one of the most exciting things you can do. People are unique, and the task of capturing a fragment of their personality is a thrilling challenge to any photographer, no matter how experienced the photographer is.

Pointing a camera at someone, yelling "smile," and clicking the button isn't going to get you very far, though. You've got to connect with people to really show off their best side.

There are no hard and fast rules for good photos ...

There is no dark art to making people look good in photographs, but you do have to pay attention to make it all come together in a snazzy way. The people in your photo have to look good, the background has to be tasteful, and the overall feel of the photo has to work well.

Ultimately, though Ansel Adams had it right: There are no rules for good photos. Just good photos. Develop your gut instinct and follow it; great pictures will come with practice.

It's all about the eyes

The very first thing you need to know about getting people to look awesome is that their eyes have to be in focus. This is absolutely, completely nonnegotiable. If they have their eyes open, get them in focus. If they have them closed, get them in focus. Is your model wearing sunglasses? Well, get *them* in focus. You see where I'm going with this?

Get the eyes in focus. Everything else will fall into place.

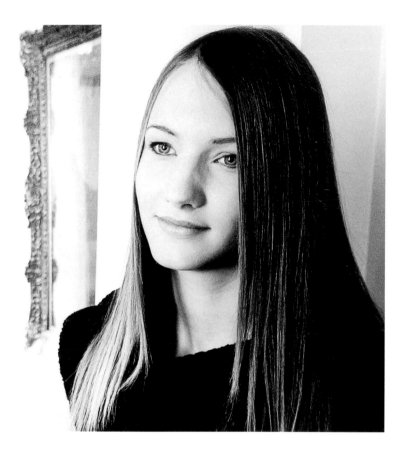

portraiture, concentrate 100% on getting the eyes right. Trust me: Everything else will eventually fall into place.

Focusing and composing your portraits

If the eyes are so incredibly important, how can you ensure that you get them in focus? Taking a photo is a multistep process. First of all, check your camera settings. Is your camera in the right file format? Are you in the correct autofocus mode? Is your camera in the camera mode you were planning to use? Is your ISO set correctly?

Next, check your exposure. If you're shooting in Program, Aperture Priority, or Shutter Priority mode, you need to ensure that you haven't changed the exposure bias. If you have ventured into manual exposure, you should check whether you've dialed in a useful aperture. And if you are in a fully automatic mode, you should turn to Chapter 3, "Photography Basics," and be deeply ashamed of yourself.

The reason for focusing on the eyes is simple: Whatever your photo, this is really where you want your audience to be looking. In a good portrait, the eyes are a window into the soul, and if you want to move people with your shots, it's important to get (make) that connection.

As you are starting out on your journey of improving your

The final steps are to focus and compose your image:

The first step to get your focus right is to zoom all the way in on the eyes of your subject. This helps the camera's focusing mechanism get the focus right, and it reduces the risk of the camera focusing on the wrong thing. Obviously, if you are shooting with a prime lens (i.e., a nonzoom lens), this step doesn't apply.

Now, half-press your shutter button. Your lens will attempt to focus. Since you've zoomed all the way in, it will be very clear when your subject is properly in focus. If your lens gets it wrong somehow, let go of the shutter button and half-press it one more time. Once your subject is in focus, keep the shutter half-pressed.

3

Now, while keeping the shutter button halfway down, you can zoom back out, and compose your photo. Take your time, there's no rush.

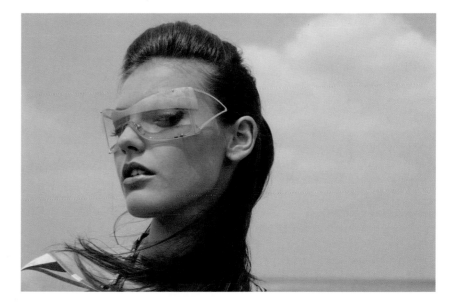

4

When you're happy with the way your photo looks through the viewfinder, all you need to do is to press the shutter all the way down, and your camera will take the photo.

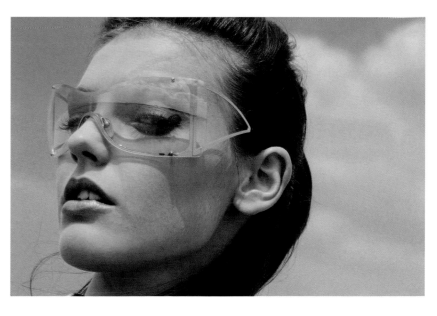

Putting your models at ease

The first time you do a photo shoot with someone who hasn't done a lot of modeling, you'll probably find that directing him or her is deceptively difficult. The images you have in your head might be difficult to put into words, but that is only half the battle. The real issue is that people tend to be quite tense in front of a camera. Some subjects are better than others, but some never really get used to the tension of staring into the front of a lens. I know at least one relatively famous fashion model who still drinks half a bottle of wine before any photo shoot.

There are a few things you can do to keep people at ease, however. If your models aren't used to being in front of the camera or they are nervous, it is often better to give them less direction to begin with. If you are in a studio setting, you're already in a slightly odd situation, but even in more natural surroundings, the stress of being in front of a camera can put people ill at ease. Trust me: If your subjects aren't comfortable, your photos aren't going to come out great.

A photo shoot is meant to be fun—so have fun with it!

When I first started out taking photos of people, I was often worried about "getting it wrong," and as such, I spent a lot of time checking and double-checking my camera equipment, flashes, and so on. It meant that the photos turned out okay technically, but in retrospect, none of them was very good. Why? Simple: I didn't have rapport with my subjects because I didn't spend enough time actually talking to them.

To ensure that you connect properly with your subjects, make sure that you spend some time talking to them. Be yourself, explain what you're hoping to achieve with the shoot, and ask them if they have any ideas. Find out something about your models: Do they have any hobbies or passions you can incorporate into

the shoot? Anything you can do to break the ice will make a huge difference to the final results.

You can't force people to relax, but there are a few things you can do to help them along. One exercise worth trying is to get them to stand on their tippy toes for 20 seconds or so, and then stand back down on their heels, normally. Get them to pretend to be a tree—deeply rooted, as if they are never going to go anywhere ever again. Encourage them to envision roots growing

out of their feet and into the ground they're standing on. For some people, this "grounding exercise" works. Mostly, though, everybody in the room feels so ridiculous that lots of laughter ensues. Perfect: It's a win-win situation. Everybody is relaxed and ready to take photos.

Directing models

Learning to direct people verbally can be a challenge, but I've found that there's a simple trick you can

Working with professional models makes direction easier— but don't give up on amateurs too easily.

As for the actual poses, one thing you can do right now is to keep a *swipe file*. Whenever you see a photo you like on the Internet, print it out. Spot a cool pose or lighting idea in a magazine? Cut it out. See a cool billboard or poster? Take a photo of it (with your camera phone, if you have to), and print that too. Collect all of these clippings in a binder, and bring it with you to the shoots. Not only can you point to specific examples of what you'd like to do, but you can also talk to the models about what they like (and dislike). Sharing one good idea might be all you need to get your photo shoot on the right track.

Catchlights

Remember what we said about the eyes being really important? That's true, of course, but eyes have to look engaged and alive, too. You may not have noticed this consciously, but you'll find that many good portraits have reflections in the subjects' eyes: from a flash, from the sun, or from some other light source.

These reflections are known as *catchlights*, and while they are relatively subtle, they make an

use to make it all easier: Show, don't tell. It's much easier to say "Do this" and leap in the air than to try to describe what you want. You may feel silly, but that's OK: Why should your models be the only ones feeling daft? Even better: If you both end up laughing, some of the tension is gone.

Don't be afraid to make a fool of yourself, and, most important, have fun with it. I've found that how good a photo shoot turns out is directly proportional to

how much goofing around we've done in (or outside) the studio. Fashion shoots especially—if people are antsy, on edge, or worried about the outcome, it's going to be really hard work to achieve the photos you were dreaming of.

A photo shoot should rarely be quiet. Play some music if you can, dance if you want to (that goes both for the photographer and the models), talk lots, and have fun with it.

*Catchlights:
It doesn't take much, but there's a huge difference.*

incredible difference to how people perceive your portraits. Without catchlights, portraits can look dead and lifeless.

Obviously, there are many situations where catchlights wouldn't occur naturally in a photograph. Luckily, we are crafty photographers, so we can just add them in! Even if you have plenty of light, you can add a catchlight by turning on a light source near your subject.

If you'd rather use flash to add your catchlights, try turning on the flash on your camera. If you have an external flash, use that

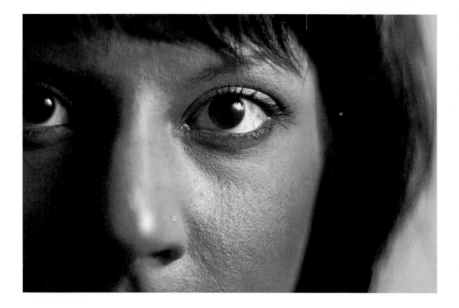

Taking photos from a low angle tends to make people look imposing and dramatic—think of the famous scene from *Reservoir Dogs*, shot from below with everybody walking toward the camera, for example.

One thing to be aware of, however, is that it's actually quite difficult to make people look good from below; if the person you're taking a photo of looks down, even the slimmest of people will end up with a double chin, which doesn't look great. With the from-below shot, we're going for attitude, so it doesn't really matter if the subject isn't looking into the camera lens: Ham up the arrogance and sassiness, and you may end up with a fantastic shot.

When you're taking photos of children, taking photos from below can work well, too. Children are photogenic, but because of their diminutive stature, you tend to be used to seeing them from above. Get down to their level—or lower, if you don't mind getting down on the ground—and you get a very different perspective than usual, with the possibilities of getting some lovely, unusual portraits.

instead. Use the *flash exposure bias* to set the flash to as low an output as you can, and shoot the picture in fully manual mode. Voilà! You have a photo with lovely sparkling eyes, without any hassle.

If you're shooting outdoors and find that your photos are lacking sparkle, consider adding a reflector to the lighting setup. Reflecting sunlight into your model's face can add sparkle and life just as easily as adding catchlights in any other way.

Shooting from below

Hopefully you've started to get a feel for how you can get people to look pretty decent, but so far the photos have all been taken pretty much straight-on. It's a common thing to do, because as human beings, we're used to being able to see people straight in the eyes, more or less. And yet, you can achieve a lot of drama by taking an unusual approach to your photographs. Doing this is simple: Get up high or down low!

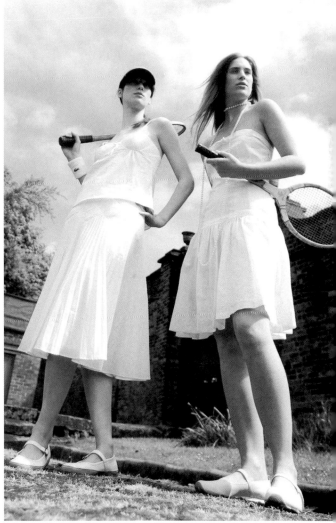

Shooting from above

Taking a portrait from above works well: You get a connotation of slight submissiveness and perhaps a more flirtatious feel to the photo. Hey, it isn't for nothing that the ubiquitous MySpace self-portrait is taken by holding a camera up and photographing back at yourself. It makes people look slimmer and more attractive!

Stand on a chair, climb a stepladder, or buy a jetpack: It doesn't matter how you get up in the air, as long as you are able to get (slightly) above your models. Shooting from above can make a big difference to how your photos are perceived.

When using this technique, it may be worth considering a wide-angle lens for extra dramatic effect. The way a wide-angle lens works makes heads appear significantly bigger than bodies, creating a comic effect. Alternatively, if you move a little bit farther away from your model, the fact that his or her feet appear so small makes your model look a lot taller!

Composition rules

Put simply, composition is the art of deciding what goes in your photo and where in the frame your subjects are placed. You can affect the composition of a photograph in many ways, such as using a telephoto lens

to capture a thin sliver of reality or a wide-angle lens to take a broader view. You can move your subjects around, or you can move yourself and your camera. All of these things make a difference to how your final photo will look, and you have to consider all of it in the process of taking your photo.

There are whole books written about composition, and even when you think you've learned everything there is to know about photography, you'll still discover that some clever photographer somewhere does something with composition that you've never even considered. I can't possibly teach you everything there is to know about composition in a few pages, although I can give you a few tips that will make it easier to get the photos you want.

Keep an eye on your background

It always amazes me how many aspiring photographers, when they start really getting the hang of things, often pay little attention to the background in their photos.

It's easily done. By the time you've gone through the checklist of

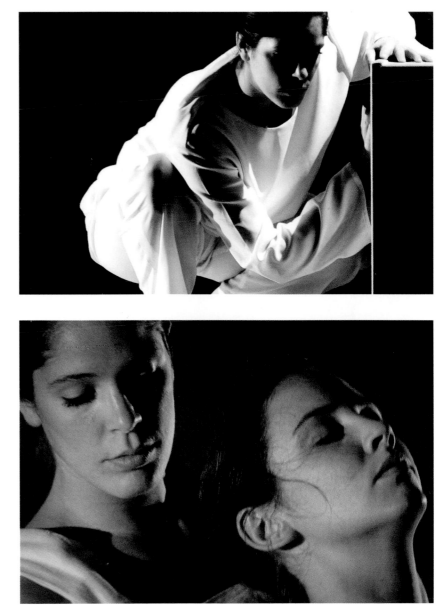

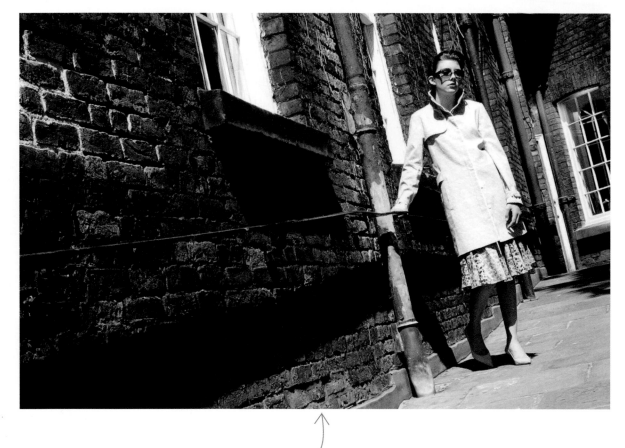

A messy background can really distract from the main subjects.

all the things you need to think about, the background is pretty far down the list, but when it comes to getting well-polished photos, it is well worth keeping an eye on what's going on in the background. The cleaner and less disturbing the background, the more people will notice your main subject, and that's certainly a good thing when you're working in portraiture.

There are a few ways you can ensure the backgrounds look better:

1 Move your subject: If possible, ask your models to move away from a messy background and to a plainer background. The difference is huge!

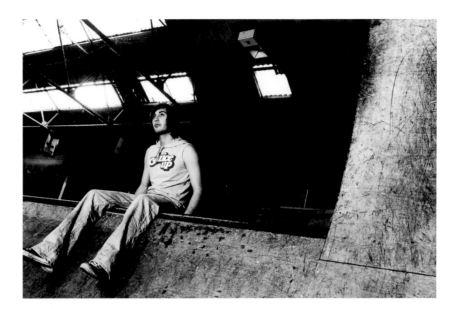

2 Move yourself: If you can't move your subject, can you move left or right? This will change your perspective and can move disturbing elements out of the image.

Shoot with a large aperture: If you shoot with a long lens (say, a 100mm focal length) and a decent aperture (f/2.8, perhaps), you can throw the background out of focus quite easily. A blurry background helps the viewer to concentrate on your main subject. Combine this tip with Step 1 or Step 2 for even better effect!

Darken the background: For additional effect, you can either darken the background (by blocking out the light that would otherwise hit it), or brighten your main subject using artificial light. The difference in brightness and contrast makes a great difference in how the viewer perceives the background.

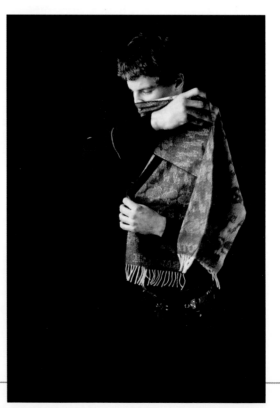

The Rule of Thirds

You may have heard of the Rule of Thirds. It's one of the most often applied "rules" in photography. Why? Because it works really well. The idea is that you place the key parts of your photos along an imaginary tri-section of your photo. For some reason, the human brain is programmed in a way that perceives photos composed following the Rule of Thirds more positively than photos taken in a "bull's-eye" style, or straight on.

I should probably let you in on a secret: Usually, though I keep the Rule of Thirds and other composition guidelines in mind, mostly I'm concentrating on the technical aspects of the photo, such as a difficult lighting situation or figuring out what to do when a scene is changing rapidly. It's important to get the subject in focus and the exposures right for the photos. As to composition, you can always crop the photos later, which is what I do if I need to.

I recently photographed the London World Naked Bike Ride, and with people flying by on bikes at high speed, I didn't have time to think about composition so much. But it's good to keep it at the back of your mind, so you can recompose the image digitally later.

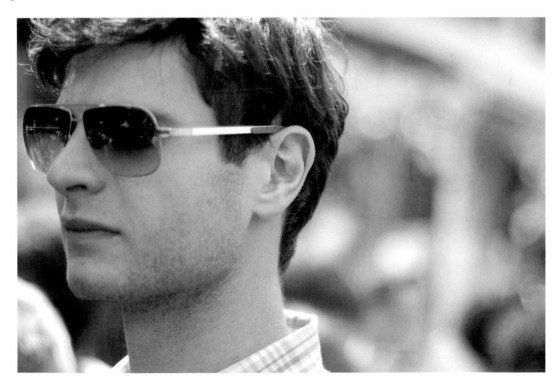

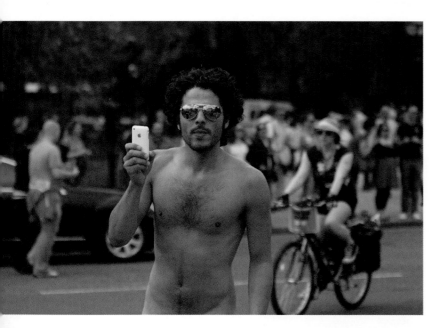

1

If you're under pressure, concentrate on exactly one thing: getting the shot. If you can start planning for composition already at the time of shooting, all the better, but if you don't get the exposures on your memory card, all bets are off.

2

Once you have the photos, you can consider cropping them digitally. In this shot, I used the Rule of Thirds to determine how I did the crop. I also rotated it slightly to add a sense of speed, and a dynamic edge to the picture.

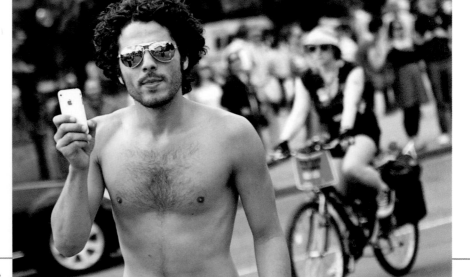

By overlaying the Rule of Thirds lines over the photograph, you can see that it actually matches up very closely. The model's face and body fall neatly into the top-left third intersection of the lines. The cyclist in the background falls more or less into the top-right third. Splendid!

Leading lines

Apart from the Rule of Thirds, you can use the principle of leading lines to add impact to your photographs. The idea here is to use cues to lead a viewer's eye to a particular part of the photo. In effect, what you are doing is utilizing part of your shot as a huge red arrow pointing at what you want the viewer to see.

A well-used leading line will make a part of the photo seem almost magnetic—you can't not look at it. When you scan the picture with your eyes, you'll always somehow end up in the same place.

Using leading lines is not hard, but you do have to be on the lookout to find good ones to use. Roads, railway lines, trees, and even groups of people can be used to great effect.

Negative space for a positive impact

Hand-in-hand with the Rule of Thirds is the idea of *negative space*—meaning the space that isn't your main subject. Used carefully, this "absence of anything" can be used not only to draw attention to the people in your photos, but also to give an image room to breathe. Even

You may not even spot the person in this photo, because the lines lead your eyes in the wrong direction.

The leading line in this photo is the musical instrument the person is playing— it almost forces your eyes toward his face.

if you zoom in quite a lot, giving the photos a little bit of space can add a sense of life to the pictures.

Adding negative space is easy—you just shoot wider than you would usually do. As a result, you'll have a lot of space in your frame that isn't your main subject. It helps to be mindful of whether the presence of this space actually adds to your photo. Great negative space effects come from the interrelation between the various subjects in your photo. After all, there is no point in using up valuable photo area if there isn't any benefit to be had.

Negative space can enhance the relationships between people and things in a given space. Its use depends on your photographic style and on your personal preferences. Some photographers use negative space with very impressive results indeed; if you want to be among them, it may be a good idea to give the technique a try.

Rules are meant to be broken

This chapter presented a lot of practical tips, but ultimately none of them are laws. It is a good idea

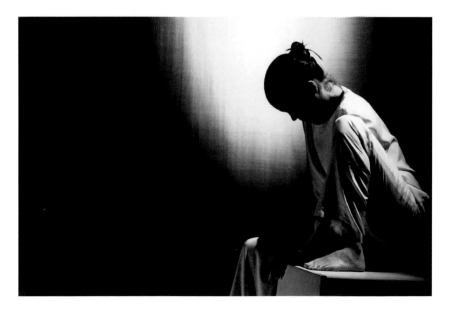

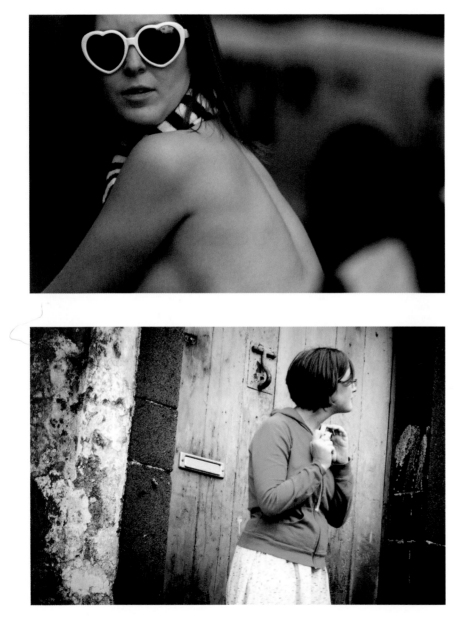

to try to adhere to the rules and tips in this chapter, at least for a while. In this way, you will learn to understand the benefits of each rule, why it exists, and how it helps you take better photos.

After that, when you start getting the hang of portrait photography, you'll probably want to start breaking the rules. We're photographers, not tax inspectors. As photographers, we are rebels, outcasts, and rule breakers, the whole gang of us! Do keep in mind how to take the very best photos: by knowing what the "rules" are and then making a conscious decision to break them to achieve a particular effect and personal style.

Even if you are acting on your photographic instincts, it helps to be able to defend your choices. Why were you shooting at ISO 400 instead of ISO 200? Why did you decide to focus on something other than the person's eyes? Why did you choose to ignore the Rule of Thirds for a particular photo? You don't have to defend your choices to me or to anybody else, but you should be able to sit down and think about a photo and replay the choices you made in your head.

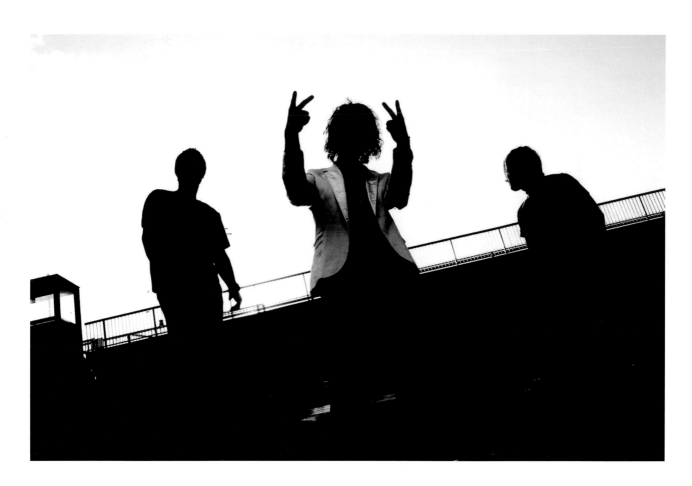

If you can't defend your own choices, it's likely there were elements of your photo that you didn't consider. Not a problem if you have an awesome photo on your hands, but remember, the very best photographers don't leave anything to chance. By over-thinking, over-planning and over-analyzing, you are developing your photographic instincts faster than you could ever imagine.

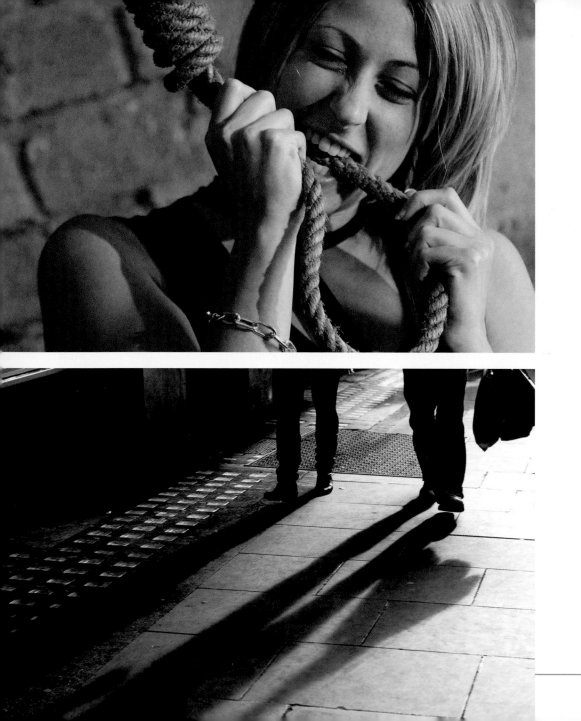

Getting Creative

THE FIRST FEW CHAPTERS of this book focused on some of the basic concepts of portraiture. Now it's time to dive head-first into the fun stuff: making people look awesome by adding a bit of creative flair into the mix.

Photography is an incredibly flexible approach to creating small masterpieces of art. Getting a portrait that really speaks to your audience is about a lot more than pointing a camera at somebody and clicking the button. It's extremely rare that you'll get truly fantastic photos by pure chance—you're going to have to fight for them. Luckily, there are a few techniques you can try that should really spruce up your photographs.

Without further ado ... I present you with a lovely cheat sheet of a chapter that you can use to move your portraiture into the fast lane.

From portraits to awesome *portraits*

More than anything else, photography is about capturing light. It makes sense, then, that you can take more eye-catching photos if you're especially aware about what your light is doing.

Light comes in many flavors—different intensities, directions, and colors—and all of these have an impact on what your photos of people look like. It's not difficult to start experimenting, and in the process you'll learn to take some fantastic portraits.

High-key portraiture

We covered several ways of making photos look different in the previous chapter, including ways of cropping your images. However, certain stylistic choices go beyond that. The settings in your camera and where you point it obviously affect your photos, but the long list of options available to you most certainly don't stop there!

Two powerful techniques you can use to convey emotions in a photograph are to use high-key or low-key lighting.

In high-key lighting, you are aiming to create a very light and airy atmosphere: You're aiming for low contrast and bright tones, a combination that has connotations with light-heartedness, happiness, beauty, and optimism.

The particular challenge with high-key photography in general (and portraiture in particular) is to get the lighting right. Although it helps, you don't need to use expensive studio lighting equipment; just make sure that your light is smooth and soft

and that the photo is nice and bright without being grossly over-exposed.

The idea is to get less harsh shadows than you normally would, to get that dreamy feel we're aiming for. You can do this by ensuring the light comes from all directions. A reflector may come in handy, which you would use to deflect light back at your subject, or use a diffuser between your subject and the light source to ensure nice, soft lighting.

High-key portraits give a light, airy feel.

Low-key portraiture

Now that you are familiar with high-key photography, it won't come as a huge surprise that low-key is the opposite.

In a word, low-key photography is "moody." We're looking for brooding emotions, hints of melancholy, and a lot of darkness. In fact, the more of the picture that's dark, the better. What we're really going for is the hint of a shape. With some of the best low-key photos, you only see the simplest outline of your subject. As you've probably figured out already, negative space is of the utmost importance here.

There are many ways you can arrange the lighting to get appealing low-key shots, but the easiest way is to set up the lighting specifically for these shots. Shoot in a darkened room, and use a single spotlight from the side. Make sure you *shape* the light (a couple of pieces of cardboard should do the trick) so your light doesn't hit the background or anything else you don't want in your photos.

In low-key photography, less is more.

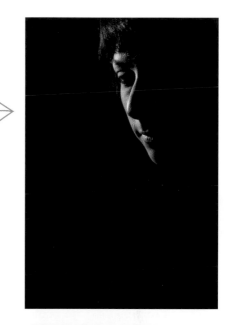

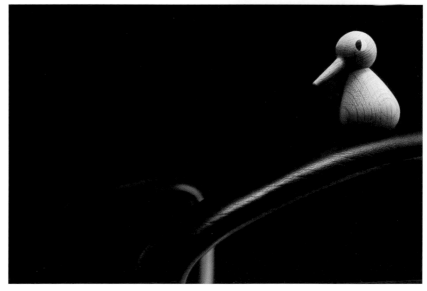

It's possible to get low-key photos without fiddling with light, but it's always going to take a single, quite powerful light source, without much other light hitting the scene. Bright sunlight could do the trick. Surprising as it sounds, you can take some truly great low-key portraits in bright sunlight. The trick is to ensure that your subject is in the sun, and the background in the shade. Because of the huge difference in light levels between the foreground and the background, the background will come out much darker. By upping the contrast a little bit when you're preparing the photo in post-production, you can make your pictures sizzle as low-key shots.

Back-lighting

Most of the time when working with portraiture, you want your subjects to be well lit. Let's face it, though: A bit of variety is good for the soul, and it's certainly a good idea to look into alternative lighting techniques to spice up your photography portfolio a little bit.

One way you can change things up is to do the exact opposite

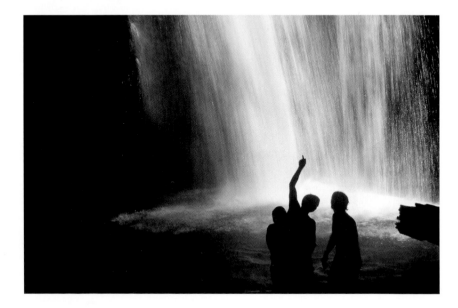

of what you would normally do. That includes photographing people facing away from the camera, cropping half their face off, and doing funky things with lighting. Normally, you would light people from the front, but you can get some pretty awesome results by lighting people from the back, too. Yes, this means you're photographing into the light, which is an interesting challenge at the best of times, but people look pretty cool in silhouette, and you can get some really awesome other effects, too.

To get good silhouettes, it's usually easiest to make sure you have a large, evenly lit surface. Pointing a flash or a flood lamp at a white wall and having your model stand in front of the wall is a great way of getting this effect. The infamous "person in sunset" shot also works great, for much of the same reason: At sunset, the horizon turns a lovely, even shade of a color, which makes your silhouette show up clearly.

The biggest challenge in getting your back-lit photos right is that you have to expose for the background; that means you will probably need to use manual camera settings to ensure that the

background is exposed correctly. As you can imagine, a well-lit, correctly exposed background and an unlit foreground means that the foreground comes out dark—but that's fine, because it's precisely the effect we are going for in these shots.

Once you've got your exposure set correctly, pay extra attention to your focus: Because you want a nice, clean silhouette, you'll want to ensure that your foreground is crisply in focus.

Side-lighting

A little less dramatic than back-lighting, side-lighting still has a warm place in my heart. It's very easy to get people looking unusual and emotive with a strong light from the side—and it's a great learning process, too. The funny thing about side-lighting is that you often learn new things about your models. It brings out flaws that you may never have even noticed before, but it also occasionally shows

Combine several of the techniques in this chapter for extra-creative mojo.

a completely unknown beauty, which can lead to some very powerful portraits.

Side-lighting can be done in different ways; any light source will do, but it helps if your lights are quite flexible. You'll want to move them about and change their intensity to get the photos you're aiming for, so dimmable floodlights or strobes might be a good approach.

Remember that there aren't really any rules for how you get your best photos. You could decide to get all light from one side or you can light both sides of the face.

If you decide to light from both sides, experiment with making one of the lights brighter than the other; a slight difference in brightness on either side can give a beautiful sense of depth in your photographs.

Get in close ... no, closer

I'll be the first to admit that "getting closer" is not a universal photography rule, but I have a strong personal preference for getting in close. I really like it when I see portraits where you're close enough that you feel you can touch the person in the photo.

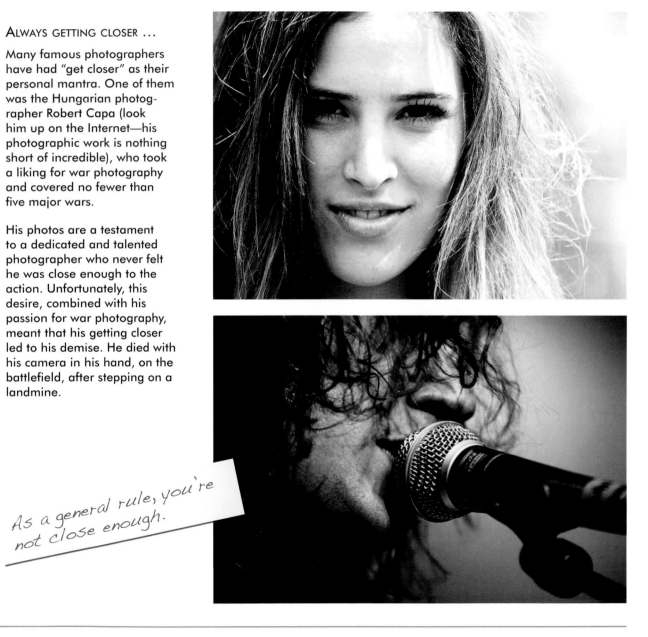

Always getting closer …

Many famous photographers have had "get closer" as their personal mantra. One of them was the Hungarian photographer Robert Capa (look him up on the Internet—his photographic work is nothing short of incredible), who took a liking for war photography and covered no fewer than five major wars.

His photos are a testament to a dedicated and talented photographer who never felt he was close enough to the action. Unfortunately, this desire, combined with his passion for war photography, meant that his getting closer led to his demise. He died with his camera in his hand, on the battlefield, after stepping on a landmine.

As a general rule, you're not close enough.

Most people who are just starting out in photography are caught in the "Oh no, I mustn't cut the top of their heads off" mode. As a result, they often end up zooming out too far or moving too far back. There's absolutely no reason to: Get in close and personal. There is a lot of beauty in being able to see eyes, the small smiling wrinkles in a face, and every tiny detail of skin.

Psychologically, getting in very close works well because you actually very rarely see only such a small part of a person. It takes you well inside his or her personal boundaries, a place usually reserved for family, close friends, lovers, or complete strangers on the metro. Of course, a photograph is different from any of these experiences, but nothing is stopping you from using all the tricks in the book to get your photographs to be as intimate as possible.

To get in close, you can move closer physically, but you might find that not everybody is comfortable with getting a lens too close to his or her face. Using a zoom lens is the way around this: You can get beautiful, intimate portraits from across the room with a 200mm lens, for example. Alternatively,

as discussed in Chapter 4, "Composition and Making People Look Good," and Chapter 7, "Photo Editing," don't hesitate to crop your photos to get in closer after the fact.

Creative use of colors

As humans, we have a strong reaction to colors, and using them to full effect in portraiture is a very good idea. Colorful makeup is one way you can brighten up somebody's face, but you can go much further

than that, too. Clothes and backgrounds, especially, can look fantastic in vibrant colors.

If you're feeling flashy, you can add colored gels to your strobes or lights to add some extra color to your photos, too. The great thing about gelled strobes is that you can paint a wall in 1/60 of a second—and repaint it just as quickly in a different color. It's not the most original of techniques, but it's perfect for adding a lick of awesome to your photos.

Sometimes, a touch of color can make or break a photo.

In extremely poor lighting, black and white can be a savior of a photo that's otherwise useless.

The other thing you can consider is to desaturate parts of your photos—a great way to draw attention to your photographs. I'll go into more detail about how you can do that in Chapter 7, "Photo Editing."

Black and white

You'll have spotted quite a few black and white photos in this book already—and for good reason. Monochromatic images have been part of photography ever since people started taking pictures.

Not all photos work well in black and white. This one, used on the cover of this book, loses much of its impact when monochromatic.

The great thing about black and white photography is that you abstract what you are looking at in a lovely way: With well-balanced color photographs, you are, in a sense, documenting something that happened. In black and white, you remove the distraction of color, and you're left with texture, form, and light. Whether you opt for subtlety or all-out high-contrast black and white photos, the results can be stunning—and they'll have that air of old-fashioned artistic integrity about them, too.

Deciding to turn a photo into black and white is best done in the digital darkroom, as it gives you most flexibility. We'll talk more about different ways of turning a photo into black and white in Chapter 7, "Photo Editing," but for now, have a

Pure black and white works for some photos; for others, a slight sepia or color effect works better. Experiment to find what works.

think about how you decide whether a photo should be in color or in black and white.

Personally, I look at most of my photos in black and white at some point, simply because it helps me visualize the potential of a photo. Then, after I have done that, I sometimes decide that the color available in the image really adds to the photo as a whole. Perhaps color adds to the mood, or makes the photo more interesting. If that's the case, obviously, the photo "wants" to be in color. If there isn't much of a difference, or, even better, if the photo looks better in black and white, I'll start the process of doing a proper black and white conversion.

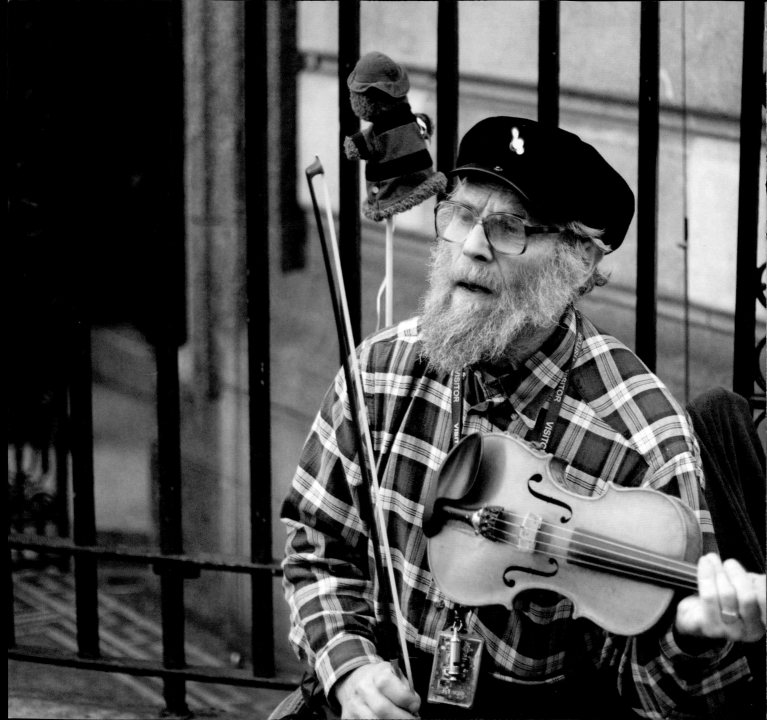

Street Photography

ONE PROBLEM WITH PHOTOGRAPHING PEOPLE is that people often act different when they know they are being photographed. Most of us aren't too comfortable in front of the camera, but even those who are tend to pose or behave unnaturally when a lens is pointed at them.

Street photography overcomes this problem. Instead of asking for permission, setting up lights, and working with your subjects, you are photographing people in their "natural habitat." You might capture a businessman engrossed in a conversation on his BlackBerry on his way to work, a street performer taking a rest, or a tourist in awe of a famous monument. What these scenes have in common is that you couldn't stage them if you tried. They happen for a fraction of a second, and then the moment is gone.

The quickest way to get the feel for street photography is simply to go for a walk where you are likely to find people. Every time you see something where you think, "Oh, I wish I could have taken a photo of that," you've spotted an opportunity for street photography.

Key points in this chapter

The important thing about street photography is to capture people doing what they do best: living their lives.

Taking photos of people "doing their thing" might sound mundane, and more trouble than it is worth, but believe me, street photography, once you start getting the knack of it, is intensely awarding. Look up some of the greats on the Internet—Diane Arbus, Helen Levitt, Saul Leitner, Leonard Freed, Henri Cartier-Bresson, Tina Modotti, Bruce Davidson, Garry Winogrand—to get a thorough introduction to the genre.

As an extra bonus, training yourself to see people in their natural environment helps you take better formal portraits, too.

It sounds easy, but street photography is incredibly tricky to get right. For one thing, there are no second attempts at a photo. I often spend whole afternoons taking photos without capturing a single useful photo. But the pictures you do capture are natural and beautiful and can show an environment or community in a unique way. Grab your camera; have a go!

Choose your weapons

There are a few different approaches to street photography, and the equipment you'll need will depend on the method you choose.

Catching people unawares often helps capture the feel of a location—in this case, a flower market in London.

Personally, I am a huge fan of getting up close and personal with my subject, and snapping photos of people quite openly. To do this, I find that using an entry-level camera body works very well. In fact, most of the photos in this book are taken with a Canon Digital Rebel XSi (a.k.a. the EOS 450D).

In addition to a smallish camera body, I love to use a nice, fast prime lens. A 50mm f/1.8 works great, or you can use a 50mm f/1.4 if you want to spend a little more money. The advantage of prime lenses is that they have huge maximum apertures, which means you can isolate your subject from the background more easily.

Street photography is one of the few fields of portraiture where an SLR isn't necessarily the best choice. A Leica M8 or M9 costs a small fortune, but it is quiet and great for sneaky pictures. If you're not ready to remortgage your house to buy a camera, a compact-SLR hybrid camera like the Olympus E-P1 or the Panasonic Lumix DMC-GF1, or a high-end digital compact like a Canon G11 are perfect options for street photography.

If you prefer to keep your distance, a tele-zoom like a 70–200mm lens is ideal, but many lenses with this zoom range tend to be quite big and make you look like paparazzi. People aren't too fond of paparazzi, and I've occasionally landed myself in a spot of bother with people who took offense at being photographed.

Photos taken in "gritty" areas really appeal to me, but if your subjects are up to no good, looking like an undercover police officer is not going to win you the Most Popular Person in the Street award.

I find that I get much less grief when I'm working with a smaller lens and camera when shooting off the beaten track.

Using a large aperture helps throw the background out of focus: A great way of ensuring your background looks good!

For a quick refresher on apertures, turn to Chapter 3, "Photography Basics."

Taking photos on the sly

How you decide to approach street photography will to a large extent depend on your personality. If you're quite confident and

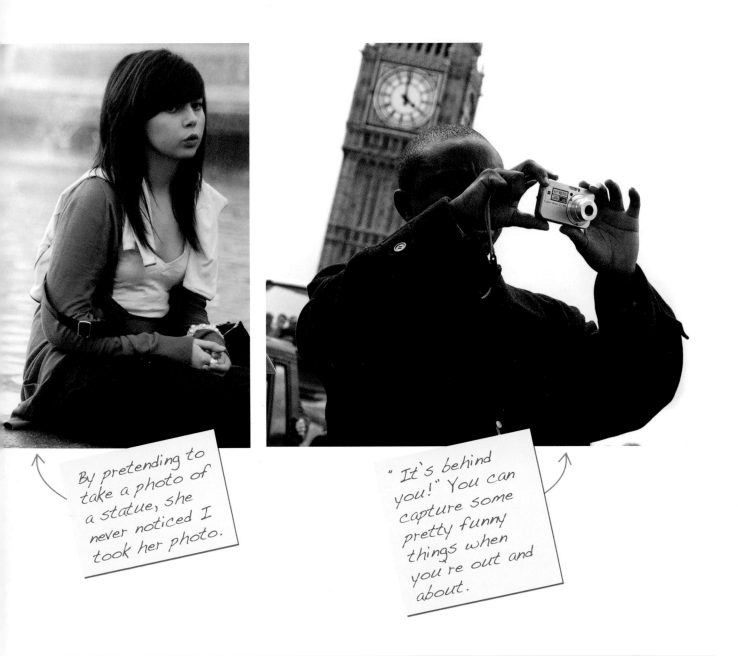

By pretending to take a photo of a statue, she never noticed I took her photo.

" It's behind you!" You can capture some pretty funny things when you're out and about.

don't mind the occasional confrontation, you can do pretty much whatever you like. It's worth being aware, however, that people's attitudes and postures change if they realize they are being photographed. In some circumstances, people reacting to the camera—or even posing for you—is no problem at all. Other times, though, you might find it's not working, because their reaction damages the mood you were trying to capture.

I'm a huge fan of taking photos sneakily. Busy street markets, shopping streets, and events are great places to get some practice. Often, I'll simply take up a position near a busy intersection, market stall, or street where many people are milling around and interacting. If the light doesn't change much, I'll set my camera to Manual Exposure mode, take a couple of test shots to ensure the exposure is right, and then just loiter for

a while. When I see something interesting, I'll just quickly lift my camera to my eye, frame the shot, click the shutter, and keep my fingers crossed that I got a good picture.

In locations with lots of tourists, you'll often find people from all over the world: a prime opportunity for street photography. In these situations, I'll often take a slightly different approach. Instead of just loitering around

Perhaps I'm taking "street photography" too literally here; but keep in mind that when you are shooting from the hip, you'll get quite a few failed photos. Some of them might turn out pretty awesome, though.

PICKING A CAMERA MODE

Things happen quickly when you're taking street photos, and it's important that your camera isn't holding you back in your endeavors. If you have a lens with a slow autofocus (like the otherwise fantastic Canon 50mm f/1.8 prime lens), consider using manual focus.

As for camera mode: I will always use Aperture Priority or fully Manual mode when shooting street photography. The former is great because street photography tends to look better at a large aperture, as it enables you to throw the background out of focus.

Manual mode is the go-to mode in more challenging lighting situations. Back-lighting or strong sunlight can be a nightmare for your light meter, so to assure consistent exposures, spend a bit of time setting your aperture, shutter time, and ISO ahead of shooting, then just snap away.

in one location, I'll move around a lot, and blend in with the tourist crowd. I have even been known to wear an "I heart New York" shirt when doing street photography in London, to blend in (and really confuse the hell out of people).

A great photographer once told me that if he were taking pictures of people dancing at a wedding, he would dance along, just to

try to capture the mood of the wedding. The same applies in this case: If you are taking photos at tourist locations, simply be a tourist. Sure, you're there to take photos of people, but it can't harm to get that famous clock tower in a couple of shots as well.

The great thing is that while you're aiming your camera hither and yonder, people stop paying attention to you really quickly. When holding a camera is your camouflage, taking sneaky photos of people becomes very easy indeed.

Street photography farther afield

It is great fun to take photos in your hometown, but people become a lot more exciting as soon as you leave the comforts of your own state or country. Because you don't need a lot of equipment, you can bring everything you need with you. If you ask me, you can tell a lot more about a country by photographing its people than by taking photos of bridges, castles, and forests.

Taking photos outside of your comfort zone brings some

This little boy was engrossed in his toy and just begging to be photographed.

interesting challenges right away. Some cultures have religious or cultural taboos regarding being photographed, so it's worth checking this before you travel. In other circumstances, the law might be sufficiently different that photographing people (whether openly or covertly) is a problem.

Finally, in some countries, you might find that police and security guards like to pick fights with photographers. There's not a lot you can do about it—there are jerks all over the world, and some of them wear a uniform— but it's often entirely possible to talk your way out of a sticky situation. Don't get defensive: Smile a lot, look confused, play dumb, and comply with whatever they want, as far as possible.

When I am taking photos in particularly sticky situations, I often bring many smaller memory cards: a pocket full of 500 MB memory cards isn't convenient, but it might save your day. If an authority figure picks a fight, simply take the memory card out of the camera and hand it over. Usually, they get so flustered that they refuse to take the card off you. At worst, they'll take the card (no big loss: you might lose a few photos and a practically worthless memory card),

Festivals can be a great opportunity for a bit of street photography.

YOU DON'T NEED A LOT OF EQUIPMENT

On a recent three-week trip to Vietnam, I brought exactly four pieces of photographic equipment: my entry-level Canon SLR camera, a 50mm f/1.4 prime lens, a battery, and a memory card. The sparsity of equipment was partially out of necessity: I was traveling around the country by motorcycle and couldn't bring much, but I also wanted the challenge of taking photos without having many options available to me.

Was it was a success? The photo on the front of this book was a result of that trip, so I'd say it probably was.

Don't forget to turn your camera around: The audience at a street performance can be as exciting as the performance itself.

but at least you've got a pocket full of cards to keep shooting.

Throughout all of this, keep your common sense about you. Never hand over your camera, don't start arguing, and stay polite. Being hauled off to the nearest police station to deal with a simple misunderstanding is a waste of your vacation.

Etiquette on the street

In portrait photography, your models are completely aware what they are letting themselves in for. You might have a contract (a model release or work contract) with them, you might have discussed what the plans for the shoot are, and so on.

When you're out photographing in public, things are quite different. The law is different from place to place, and people's attitude to public photography is in constant change. In most western countries, if you're in public space, you have the right to take photos, and many argue that taking photos is an extension of your human right to freedom of expression (the First Amendment in the United States or in Europe, Article 10, Section 1, of the European Convention on Human Rights).

The finer details of the law are complicated and well beyond the scope of this book, but in general, nobody can demand that you delete your photographs or hand over your camera. Do yourself a favor and Google "photographers rights" and the name of your

NAUGHTY PHOTOGRAPHY

When I took the photo of the girl playing with her hair, I was inside a large chain coffee house. That puts me on private property, but as there wasn't a sign stating that they ban photography, I am still allowed to take photos.

Since this is private property, the managers of the coffee house can ask me to stop taking photos. If I don't comply, they're perfectly within their right to call the police to have me removed from their premises.

Do remember, though, that unless there is a sign, and until you're told not to take photos, you're not doing anything wrong. They can't ask you to hand over your camera, nor can they demand that you delete photos you've already taken.

No matter how hard you try, you'll never be as cool as this guy....

If you are too nervous about photographing strangers at first, try street performers. They won't mind!

country or the country you plan to shoot in. Some websites have a handy PDF file you can download and print, which you can stick in your pocket for reference if you do get in trouble when you're out taking photos.

Far more important than the law, in my opinion, is common sense. When you're out and about, don't take photos of people who obviously don't want to be photographed, and if a security guard is telling you to stop taking photos, it's often easier to just walk away—even if he or she is wrong and you are right.

Focus on: Street photography

Is your shutter finger itching to get out there and try out some of the things in this chapter? I thought that might be the case. So, let's give street photography a go!

For this exercise, grab your local newspaper or find a website that lists local events, and find something that's happening in your area some time in the next few weeks. Found something? Great. Pack your camera, and go capture a slice of your town with it. Remember that you're photographing people: You want to capture character, flavor, and personality in your photos.

Good luck!

Photo Editing

IF YOU RECENTLY PLONKED DOWN A serious amount of cash on a gorgeous digital SLR kit, you'll be very unhappy to hear that photos taken on compact cameras tend to look better.

"What?!" I hear you scream. Yes, like you, most people are surprised by this. The fact is, camera manufacturers are very good these days at understanding their audience, and people who use compact cameras want vivid colors, nice sharp images, and they want to be able to whack them straight on Facebook or email them to grandma as soon as they've got them off the camera.

The problem with the kinds of improvements that compact cameras make before the pictures are even written to the memory card are destructive. In other words, in the process of enhancing and making the photo look "better," your compact camera is making a lot of decisions for you and, in the process, discarding information that you could have used to make creative changes to your images.

Owners of dSLR cameras tend to be more discerning. We're control freaks, of course, but for good reason: We want that little bit of extra grip on what our

Key points in this chapter

Photo editing ensures that after you've taken your photos there's even more to think about, but this is where part of the magic happens. Many photographers have moved away from seeing photography as just taking photos and more toward data gathering for post-processing.

You can't turn bad photos into good ones, so it's still very important to get the photos right in the first place, but you can turn a very good picture into a great one by tweaking it a little bit.

For more about photographing in RAW, see Chapter 3, "Photography Basics."

cards (8 GB and 16 GB are quite affordable and will store a decent number of images, even in RAW format) and if the worst should happen and one of the cards fails completely and unrecoverably, I know I haven't lost *all* of my photos.

When you copy your images off your memory card, make a backup immediately. That way, if you end up pulling an all-nighter of editing photos and in your sleep-deprived state you accidentally erase a load of photos, you still have a backup tucked away somewhere safe,

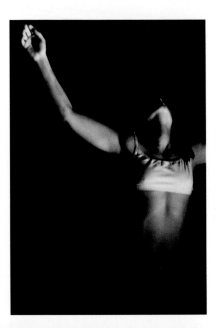

final photos look like. The first step in that process is to shoot in RAW. Doing so secures your source material. The next step is to take your photos into the digital darkroom.

Digital workflow

I know you're eager to make your photos sparkle, but it's well worth covering the boring bit first before you learn to sprinkle magical fairy dust all over your photos.

When working with digital photos, it's important to do things in the correct order. I tend to store my important shoots (such as weddings) on multiple memory cards. I bring along a few large

on an external hard drive, for example.

Next, you'll want to sort the photos. I tend to sort them into four piles:

- Useless—the model is blinking, the photo is out of focus, or one of the flashes didn't go off

- Usable—nothing technically wrong with it, just not very inspiring

- Good—I'll take a closer look at these and edit them properly

- OMG AMAZING—I deserve an award for this photo; where's my award?

After these steps, you have probably reduced your photos to about 20% of what you started with. I discard the "useless" photos altogether, but if you're not comfortable doing that, keep them around. Hard drive space is cheap, and you never know if you might want to go back to them later.

The next steps are:

- Exposure adjustment—in case you didn't get the image as well exposed as you had wanted

- Lighting adjustment—such as contrast, highlights, and shadow adjustments

- Crop and rotation

- Image cleanup—in case you have dust on your imaging sensor or suchlike

- Image retouching—removing blemishes from your model's face and body, for example

- Final crop and rotation

- Sharpening

- Saving your image

You'll notice that I crop and rotate the image twice. The first time is to stop me from retouching parts of the image that I have no intention of using anyway; the second time is the actual crop. By taking this approach, I'm giving myself the opportunity to crop into the edges of where I have been editing, which gives a better final look.

WORKFLOW SUMMARY

- **Use several large (8 GB or bigger) memory cards to spread your risk**

- **Download your images**

- **Make a backup by copying to an external hard drive**

- **Select the photos you want to edit**

- **Make your exposure and lighting adjustments**

- **Do a rough crop and rotation adjustment**

- **Image cleanup and retouching**

- **Final crop (and rotation, if necessary)**

- **Sharpen**

- **Save**

Obviously, you should continuously save your images throughout this process to ensure you don't lose your work, if your computer crashes, for example.

The "Workflow Summary" sidebar on page 111 is a handy reminder of the process; feel free to write it down as a checklist. Remember, this is merely a way I like to work. There aren't any hard and fast rules, but over the years I've adapted my workflow to be more efficient, and I've found this one to be the best.

Free software

There are approximately 100 different ways you can edit your photos. Some of the options—like a full version of Adobe Photoshop—are very expensive if you only edit the occasional photo. Others are more affordable, and there are even a few free options out there.

If you're just starting out, it's worth using a free package. Picnik (picnik.com) is a completely free online photo editing service. It is also built into Flickr: Click Edit Photo when you've uploaded a photo to Flickr, and you'll be

using Picnik. It's great for simple edits of photos, but it doesn't do too well when it comes to more granular control. It's also horribly slow at times.

Picasa (picasa.google.com) is an image management and editing software you can download to your computer. It's fast, free, and rather nifty, but you don't get that much more functionality than if you were using Picnik.

Pixlr and Picnik are great for quick crops and minor edits.

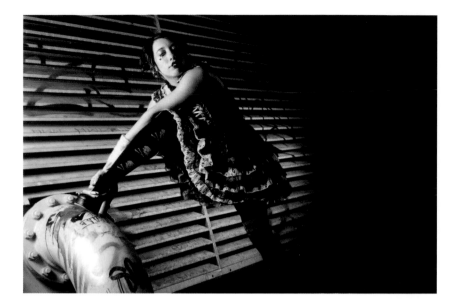

Picasa is great for a quick crop or some simple image corrections, but beyond that, you'll be struggling.

If want to keep your money in your pocket but still want the ability to edit images, take a look at GIMP (gimp.org) or Pixlr (pixlr.com). The former is a software package, and the latter a remarkably powerful image editor you can use online, right in your web browser.

I occasionally use all of the above. Picnik is great for doing quick edits to an image I've taken on my iPhone, for example, when I don't have my normal suite of software with me. GIMP is the piece of software I recommend to everybody who wants Photoshop but doesn't want to make the sizable investment. And Pixlr is fantastic for more advanced editing on the move, but I find its user interface to be a little bit alien: It's close enough to Photoshop that I get frustrated when the shortcut combinations I'm used to don't work.

If you're just starting out or you're on a budget, the free software is great to use in a pinch, or if you don't have your regular tools available. The big downside is that none of them is really powerful enough to do serious RAW file editing, which means that going the freebie route is not really a viable option for most of us when we're working on proper photo shoots.

Nonfree software

There's an excellent reason why *photoshopping* an image has become synonymous with photo editing. Adobe Photoshop has been around for over 20 years and has become an indispensable tool for digital artists, designers, and photographers all over the world.

Today, Photoshop is still an incredibly powerful tool, but it's not as good as some other software packages at image management and workflow. When you are working in RAW, it takes a considerable amount of processing power to render and display an image, which is inherently slow. Photoshop

With all the photos you are working on along the bottom of your screen, a huge workspace, and all your tools at your fingertips, Lightroom takes a bit of getting used to, but once you're hooked, you won't know how you ever got by without it.

is one of the best packages for editing a single photograph, but if you've shot 1000 photographs at a wedding, you won't want to have to open each single image to adjust it. Ironically, Photoshop is almost *too* powerful these days: I consider myself a high-level user, but while editing photographs, I use but a fraction of the features built into Photoshop.

In fact, I've nearly stopped using Photoshop altogether, because there are two other software packages that do RAW processing so much better: Apple's Aperture and Adobe's Lightroom. Personally, I use the latter, but Aperture is a very powerful and capable package with its own advantages (and disadvantages).

Adobe also makes a cheaper, cut-down consumer version of Photoshop known as Adobe Photoshop Elements. However, if you want to be able to take RAW files to their full potential, you need the full version. The bad news is that you're looking at a $700 price tag. By comparison, Adobe Lightroom costs around $300 and Aperture will set you back around $200.

The great thing about Lightroom and Aperture is that they are

nondestructive editing tools. That means that they work by taking your RAW files as the base of the editing, and then store all the changes you make to the file as a change history. That way, you never lose or change your original file, you have infinite undo stages, and you can even switch on and off various effects to see what you like best.

If you buy one piece of software, make it Adobe Lightroom: It is quick, powerful, relatively easy to

learn, and makes photo editing fast and enjoyable. I only use Photoshop for bigger compositing jobs, major airbrushing, or other high-level tomfoolery.

For the rest of this book, we won't be touching on Photoshop; put simply, with one or two exceptions, I haven't actually used Photoshop to edit any of the photos in this book. I used Lightroom exclusively. My recommendation is to buy it, learn it, and don't look back!

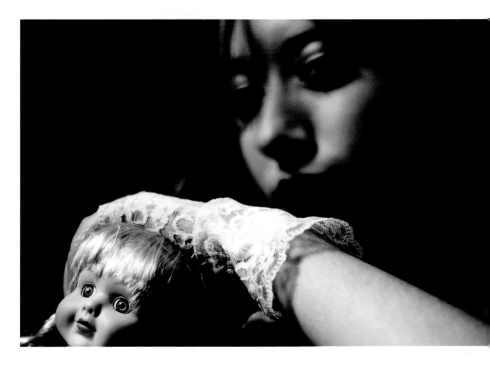

Adjusting your exposure

No matter how much time you spend trying to get your exposure right, you're unlikely to get it completely, 100% perfect. Or, put differently, I don't think I've ever taken a photo that didn't benefit from at least a little bit of an exposure correction using photo editing software.

It's just a holiday snap, but it was quite badly under-exposed and with horrible white balance problems. A quick fix and a crop later, and it's actually a half-decent portrait of a photo-loving friend of mine.

Depending on the software you choose, your approach to adjusting exposure will vary. In most software packages, there's a levels tool, which is great for exposure corrections. Most levels tools usually give you three sliders: a shadows slider (on the left side), a highlights slider (on the right side), and a midpoint slider.

Moving the shadows slider toward the middle of the histogram will "cut into" your shadows. Doing this means that more of your photo will be pure black—great to add a some moodiness to your photos. The opposite happens when you move the highlight slider toward the middle of the histogram: You'll soon see your photo becoming overexposed, and you'll start losing detail in the highlights if you overdo it.

The midtone slider is there to enable you to change the bias of the whole photo toward brighter or darker. It's perfect for when you want to make the whole picture a little brighter or darker without changing the shadows or highlights too much.

How you decide to adjust your exposure depends on the final effect you wish to accomplish. It might be that you just want to subtly brighten a photo to make it stand out more, or you may decide that a particular photo lends itself well to more creative manipulation and that more extreme measures work well. You know best what you are trying to achieve; use the tools available to create the feel you are looking for.

Saving an overexposed image

Back when I first started doing photography, digital photography was a mere twinkle in someone's wildest dreams. We were shooting on film, with all the limitations film has. One of the biggest problems is exposure. If you over-expose negative film, all bets are off: The silver halides in the film have stained to 100% and you are starting to lose data—without any possibility of recovering it again.

While film for the longest time had a more impressive dynamic range (that's the amount of data that can be captured between the brightest and the darkest part of the picture), digital cameras have quite recently caught up.

It's not always possible, but as someone who grew up shooting images on film, seeing previously overexposed areas come back and be usable is nothing short of magic. It feels as if it should be impossible, but it's happening right in front of your eyes.

So, if you've overexposed an image, don't worry, all hope is not lost. Because you shot in camera RAW, your file actually contains a lot more information than a JPG can store (and, indeed, more detail and dynamic range than an average computer monitor can show), and it is possible you may be able to recover the blown-out, overexposed areas.

In your RAW software, look for "recovery" or an "exposure" slider—move it, and see if you can regain a little bit of the blown-out areas.

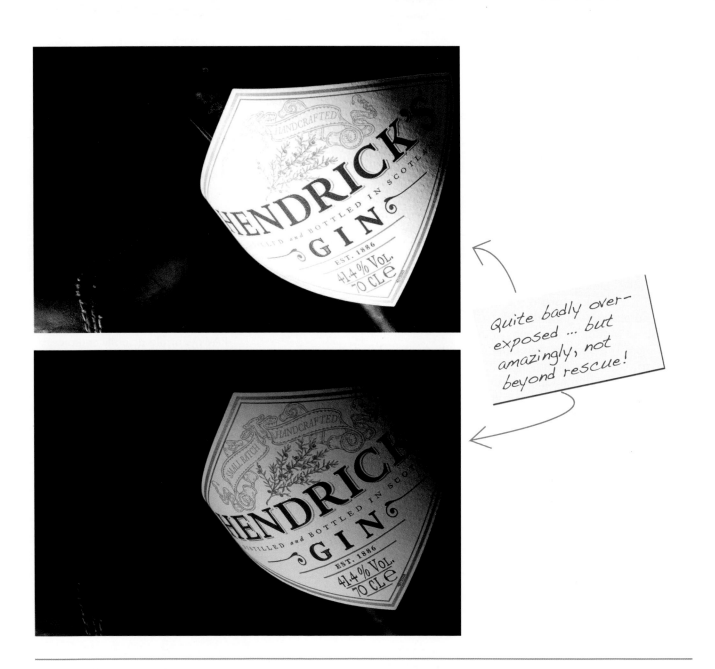

Quite badly over-exposed ... but amazingly, not beyond rescue!

Contrast

Fiddling with the exposure of your photos is only half the story when it comes to brightness. It may be useful to think of exposure corrections as fixing what you did wrong when you took the photo, while further corrections are done with creativity in mind.

The biggest of those further adjustments is likely to be contrast. You can change the look of a photograph quite significantly depending on whether you choose to take a low- or high-contrast approach to the same photo. Low-contrast photographs tend to have a more natural, gentle, innocent look to them. More contrast lends more drama and a harder look to the photo.

You don't actually have to change all that much on a photo to give it two completely different looks—look at the ones on this page, for example. Believe it or not, they are exactly the same photo, with precisely the same crop. The only thing that's changed is the contrast, and I've done some minor retouching to accentuate the differences (including making her arm lighter in one of the

photos and darker in the other, and making half her face a lot darker in the "evil twin" version).

You don't have to go to extremes, either. People subconsciously react with a feeling of "good and innocent" or "bad and evil" to photos with varying degrees of contrast. Experiment, experiment, experiment with both levels and contrast—you'll soon get the hang of it!

Cropping and rotating your photos

Of course you carefully considered how you were going to crop your photo when you were taking it. Didn't you? Don't worry about it; it's easy to forget. The great thing about digital SLR cameras is that you can use all those extra pixels to their full effect: Crop away all the bits of the photo you don't want, and you probably have more than

enough pixels left to still end up with a high-quality final picture.

All photo editing software have a crop tool built in. It's quite likely that this tool will also be able to help you rotate your photos.

Everybody will tell you that your horizon has to be perfectly straight in every single photo. That's not entirely true, but keep in mind that if it looks as if the horizon *should* be straight and it isn't, your photo will look off balance.

20100528-IMG_0925.CR2
1/1,25 sec at f / 13, ISO 100
50 mm (EF50mm f/1.4 USM)

1

Find your image, and select the Crop tool.

2

Do a rough crop to get a feel for what the picture will look like.

3

When you're rotating your photo in Lightroom, it will show a useful grid— perfect for aligning the horizon just so!

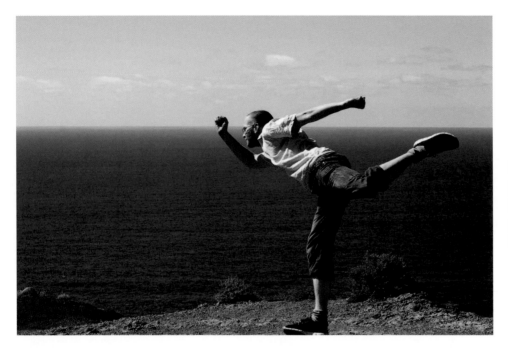

Move your crop box to where you want it, and press enter to commit the changes. Hey, presto, a perfectly cropped image!

If you have made the executive artistic decision that your photo is going to be wonky, that's fine—just make sure to exaggerate the wonkiness. That's usually all it takes to help your viewers understand that this wasn't by accident.

Finally, I'm a huge fan of keeping the aspect ratios of my photos on 3:2, but if you prefer widescreen photos (16:9), square photos (1:1), or TV-shaped photos (4:3), then

knock yourself out. You don't even have to stick to one of the accepted aspect ratios: If you feel a photo fits best as long and skinny or a nearly-square composition, then go for it. You're the photographer, and you call the shots!

Fixing your colors

Color correction is the bane of many a photographer. White balance can be notoriously hard

to get right, but if you plan ahead a little bit, you can beat the system.

What you need to do is to pick up a *gray card*. This is a piece of plastic or cardboard with a very specific neutral gray color. Get your model to hold the card and take a photo of the scene as you would do normally. You'll have to do this again every time the lighting changes.

1 Use the White Balance tool, and point your mouse at the gray card. You'll get a hugely enlarged version of the pixels around where your cursor is pointing. Select the most neutral-looking pixel, and click on it. Your whole photo will be adjusted to that one pixel.

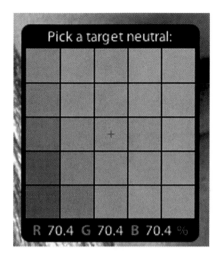

2 If your picture looks good, you've just saved yourself a load of time. Go to Edit > Copy, and you'll get the screen in this step. What you are copying in this instance is the settings you've just applied to the first image. Deselect everything, select only White Balance, and click OK.

Copy Settings...
Paste Settings
Sync Settings... ⇧⌘S

Auto White Balance ⇧⌘U
Auto Tone ⌘U

Open in Loupe
Open in Survey

Lock to Second Monitor ⇧⌘↵ Convert to Black & White

Show in Finder Presets:
Go to Folder in Library Lightroom Presets
Go to Collection ▶ B&W Creative – Antique Grayscale
 B&W Creative – Antique Light
Edit In ▶ B&W Creative – Creamtone
 B&W Creative – Cyanotype
Set Flag ▶ B&W Creative – High Contrast
Set Rating ▶ B&W Creative – Look 1
Set Color Label ▶ B&W Creative – Look 2
Add Shortcut Keyword B&W Creative – Look 3
 B&W Creative – Look 4
Add to Quick Collection B B&W Creative – Low Contrast
 B&W Creative – Selenium Tone
Stacking ▶ B&W Creative – Sepia Tone
Create Virtual Copies B&W Filter – Blue Filter
 B&W Filter – Blue Hi–Contrast Filter
Develop Settings ▶ B&W Filter – Green Filter
Metadata Presets ▶ B&W Filter – Infrared
 B&W Filter – Infrared Film Grain
Rotate Left (CCW) B&W Filter – Orange Filter
Rotate Right (CW) B&W Filter – Red Filter
 B&W Filter – Red Hi–Contrast Filter
Metadata ▶ B&W Filter – Yellow Filter
Export ▶ Color Creative – Aged Photo
 Color Creative – Bleach Bypass
Delete Photos... Color Creative – Cold Tone
 Color Creative – Color CP 1
View Options... Color Creative – Color CP 2

Now, your clipboard contains the white balance settings from your first gray-carded image. Go back to your image library, select all the photos you want to apply these white balance settings to, right-click on one of the images, choose Develop Settings, and then choose Paste Settings.

Well will you look at that! All your photos, perfectly white-balanced with beautiful neutral color tones. Of course, you can still choose to make a photo more or less cold in color tone for dramatic effect or to achieve a particular feel, but at least you're starting from a nice neutral position.

Even if you didn't think to bring a gray card, you can save a lot of money by manually white-balancing an image. Try clicking the Auto button first. Lightroom is remarkably good at white-balancing photos or at least for providing a starting point for manual adjustments. If you're not happy, try using the Eyedropper tool to find something that has a relatively neutral color tone or using the manual sliders to white-balance the image by eye.

Seems like a bit of a pain, right? Wrong! It'll save you an incredible amount of work in post-production: When you have all your photos imported into Lightroom, you can do a fantastic little trick….

Cleaning up the images

With the best tender loving care, you can't always keep dust off your imaging sensor. In some photos you won't notice it at all, yet in others the dust will show up as faint blobs of slightly darker areas. It's particularly noticeable if you're taking photos where the background is defocused, or on large areas of a bright, even color (such as skies).

I'm unhappy with the black specks on the floor in this image, so I'm going to remove them. Select the Spot Removal tool by selecting your photo, going into Develop mode, and clicking the Spot Removal tool (or press Q).

You will see that your cursor changes to a crosshair. Use the mouse scroll wheel to change the size of this crosshair to be only slightly bigger than the speck you are trying to remove. By altering as little as possible of the original image, your edits will look more natural and will be more difficult to spot in your final picture.

 You can remove the spot in two different ways. You can simply click on it, and Lightroom will try to find a suitable area of your image to sample. If Lightroom gets it wrong, or if you just want that little bit of extra control, click and hold your mouse button, and drag it to another part of the image. Lightroom will show you a live preview of what you are about to do—don't worry if the area you are sampling from is slightly brighter or darker, Lightroom will make the suitable adjustments for you.

Let go of the mouse button, and the software will make the replacement for you. Guess what? You've just done the easiest and fastest cloning job known to man! Back in the darkroom days, I would have spent hours doing this, and I wouldn't have achieved nearly as nice a result. I've gone over the rest of the black spots, too.

 The final result looks much better with a simpler, cleaner floor. It really helps the unusual composition and powerful colors to speak for themselves.

To remove the specks of dust, you use the Spot Removal tool in Lightroom. I'll show you how.... The black specks on the floor are not actually dust on the imaging sensor; I have plenty of photos *with* dust on them, but while the effect is very disturbing on a screen, the specks don't normally show up that well in print. Forgive the dramatization, but the technique is just the same for dust as for pebbles.

Fixing skin blemishes

The same technique for removing specks of dust and pebbles can be used to make a model's skin problems vanish. For this demonstration, I'll make a nose stud disappear, but you can use the technique for pretty much anything—acne, spots, scars, stray eyelashes, and so on. The Spot Removal tool in Lightroom works great on anything smallish, but if you need to do major facial reconstructive surgery, you'll have to break out Photoshop.

1

This is not a bad portrait, but it might be better without the nose stud. Being photo manipulation superheroes, we know exactly what to do. Break out the Spot Removal tool and repeat the previous steps.

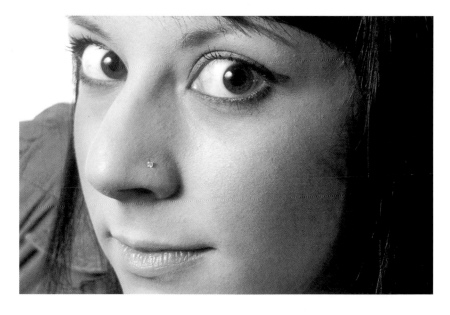

 Zoom in close so you can see what you're doing. You can't do fine image manipulation work on a zoomed-out image; it's all about precision and getting it just right. I would suggest you enlarge the photo on-screen to at least 100%.

 Drag the Spot Removal tool from the nose stud to the area you want to sample from. Again, the smaller the Spot tool is, the better.

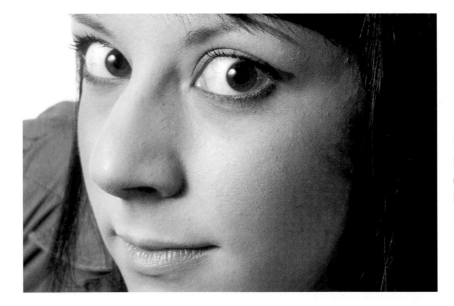

Done. I personally feel that removing the nose stud in this particular image leads your eyes to her eyes better, because there is no longer a natural focal point on her nose. Perfect!

From color to black and white

Turning photos to black and white can be really easy ... or incredibly complicated. It depends on what effects you are hoping to accomplish.

Most software have a desaturate option, where all the colors disappear like magic. But to really understand how black and white works, you need to understand how the different colors affect the way an image looks. Imagine you are looking through the world with a set of blue sunglasses. Everything that is blue will look blue, but everything red will turn black. The same is true the other way around: If you were to wear red sunglasses, red looks normal, and blue looks black. This is because of the way different colors block each other out.

When you turn a photo into black and white, in many photo editing software packages you can select which color channels to use. In Photoshop you would

Gorgeous girl, well lit, and a great pose. It could look better though. Let's see what we can do in post....

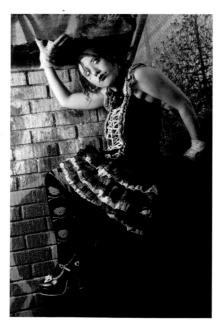

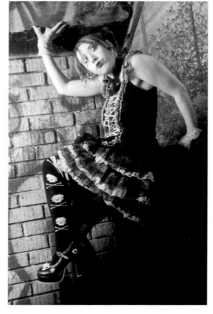

HSL / Color / B & W ▼

Black & White Mix

Red	+ 88
Orange	+ 75
Yellow	+ 29
Green	− 2
Aqua	− 58
Blue	− 8
Purple	+ 33
Magenta	+ 71

Auto

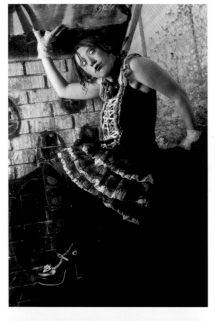

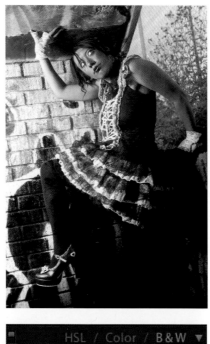

use the Channel Mixer, which gives you control over the red, blue, and green channels.
In Lightroom, control is even more granular. Let's take a look at what happens if we strongly bias one channel over another....

I've only shown how the photos look with three biases—red, green, and blue—but you have eight different sliders to play with, and each gives subtly different results depending on how you mix it all together. It's a tremendous opportunity for digital photographers: You can fine-tune your black and white photos to exactly how you want them!

I strongly encourage you to experiment with channels and play about with them to get an idea for how it all works. Be aware, however, that using a red filter tends to reduce people's skin blemishes and it makes it look like they have much fairer skin. A blue filter tends to do the opposite: If your subjects have

freckles, they'll show up extra much, and any tiny unevenness in the skin will stand out. It's an effect that works particularly well when you do black and white photos of mature men—it makes them look rugged and manly!

Pulling it all together

So, what happens when you start combining all of these techniques properly? Now you're starting to think like a true artist: Instead of just snapping photos, you are creating photographs. You're thinking about lighting, poses, a connection with your model … and about how you can make it all come together beautifully in post-production.

Take the photo on the right, for example. It's a portrait of a dear friend of mine, taken in an ad-hoc studio, with proper flashes, soft boxes, the works. I felt as if I really captured a moment here, but obviously the lighting wasn't quite there yet. The image is slightly under-exposed and quite shadowy.

It's not too great of a challenge to a Lightroom ninja, however.…

First, I turned the photo into black and white, and I applied a very soft sepia tone to lift the harshness of the black and white a little. I then used the Spot Removal tool to fix some of her minor skin blemishes. I reduced the contrast a little and increased the exposure a smidge to help the shadows in her face.

Next, I used a skin softening brush (basically, a brush set to a slight blur) to reduce some of the texture in her skin. You have to be quite careful here, because if you remove too much texture it starts to look too airbrushed, and that's not the intention.

Finally, a quick crop and a slight amount of rotation, and I ended up with a photo that is nearly unrecognizable from the original. All done in Adobe Lightroom in about 20 minutes.

It helps that the model is beautiful to begin with, of course, and a well-lit photo is always easier to work on than one that isn't, but it serves as a fabulous illustration of how a little bit of post-production can completely transform your photos for the better.

How to Learn More

NOW THAT YOU'VE MADE it this far, you're already a better portrait photographer. Your friends no longer quiver in fear when they see you coming, camera-in-hand, because you're actually starting to get the knack of it. In fact, they're quite happy to see the fresh and funky photos you've been taking of them.

This is often the place where many photographers get stuck. You've seen a steep increase in the quality of the photos you're taking, and now suddenly you're struggling for inspiration. Or you might find that you've stopped getting better all of a sudden.

It's a bit like learning to drive a car. When you first start, it's horribly confusing and frustrating. Everybody seems to be able to drive a car, so why are you struggling with it? After a few lessons, you're starting to learn faster and faster, and you improve hugely for a while. Then you actually get your driver's license, and you're left with this nagging feeling that there is more learning to be done. But suddenly it's very difficult to get better at what you love doing.

This is a natural part of any learning process, so try not to worry. This chapter, I hope, will help you along. It's designed to help you help yourself, as it were, to become a much better photographer.

The tricky part is that from here on, you're on your own. You know the basics, and short of one-on-one tuition, it's difficult for me to know exactly what

Key points in this chapter

You're never going to stop learning to be a better photographer. Your real challenge is to keep pushing yourself, to learn where to look for feedback, and to constantly evolve.

When you know where to look for inspiration, and how to actually translate that inspiration into making better photos, you're motoring in the right direction!

you're struggling with. On the bright side, there is one person who knows very well where your shortcomings are, and that's you. This chapter should help you develop from here onward…. Good luck!

Getting out of a rut

Hopefully, by now, you've taken a few portraits that you are quite proud of. It's quite tempting to use these portraits as a template for further photos; you know it worked before, so of course it's going to work again, right? Well,

that's true, but as attractive as it may be to pull nice-looking portraits out of the hat just like that, you may need to go further as a photographer.

I'm all about developing a style as a photographer, but few things make me sadder than finding

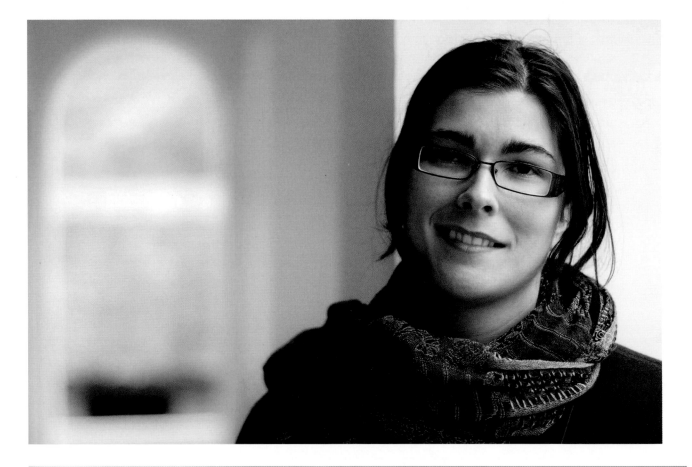

a budding new photographer's Flickr stream full of very good, but almost identical, photographs. Photography isn't just about taking good photos; it's also about keeping things interesting for you, the photographer.

One way to try to expand your horizons is to mix things up. If you normally shoot with natural lighting, try taking some artificially lit photos. If you prefer to shoot your portraits indoors, head outside, and vice versa. If you shoot mostly single models on their own, try to shoot a couple: some engagement shots, perhaps?

The key thing is to break away from your newly developed patterns. Not only does it keep things more interesting for yourself, but also it gives you a new perspective on your own template styles. If and when you decide to return to a particular style you mastered a while ago, you might discover that you've moved on and that you're ready for a different take on the same subject.

Whatever you do, you have to keep shooting. The only way you definitely won't become a better photographer is if your camera stays on the shelf or in your bag.

Learning from others' photos

There are many ways you can benefit from photos taken by others. As you may have guessed, just looking at photos helps. But to really develop as a photographer, you need to think about the bigger picture: How does a particular photograph fit into what you know already about photography, and how can you apply the things you don't know in order to improve your skills?

There is no denying that an exceptional photo creates a moving experience to the viewer. If you find a photo like that, don't stop there. Do everything you can to find out why this is the case. What does the photo mean to you? Do you think that the appeal of the photo is universal, or does your interpretation of the photo somehow influence how you feel about it?

Take an extra-close look at the lighting in a photo that you admire and try to break it down. Can you figure out where each light source is coming from and how each source affects the image? If you have to, grab a piece of paper and a pen, and

draw a diagram. Draw in the model and the camera, and try to place each of the light sources on the map you've created.

Has the photographer done anything you can't? If you wanted to, would you be able to recreate this photo? If the answer is yes, can you think of ways you could improve this photo? And if it's no, think about why not. Does the photographer in question use equipment you don't have access to? Could you make do with what you have? Could you borrow or rent the equipment you need to recreate this photo?

I'm not encouraging you to copy other photographers' photos, but it's definitely worth thinking about how you *would* copy a photo if you wanted to. The train of thoughts behind reconstructing a photo is valuable in itself, and you can learn a lot in the process.

Reconstructing a photograph

So, let's try the reconstruction game with this photo. What would you need to make this photo happen, and would it be possible to recreate it with the

stuff you already have in your photo bag?

To start at the simplest of basics: You need a location. You're in luck there—it's not as if we're hanging upside down off the side of the Empire State Building. I'm sure you can find a brick wall somewhere. Even better: the brick wall itself isn't what makes this photo, so a nice rustic wooden wall might do just as well. I'm willing to bet that you can find a suitable backdrop within a 20-minute walk from where you are right now.

The next step is finding a model. Well, that should be entirely possible as well. The girl in this photo is the singer in an industrial rock band, but we were going for the innocent Goth look in this case, so you don't have to comb through your record collection. Find a suitably adventurous teenager who is up for spending a few hours in front of a camera, and you should be all right. The makeup and hair were done by a friend of the model's; it should be easy enough to replicate as well, if you know anyone who is handy with brushes.

Two lessons are demonstrated here. One: how to reverse-engineer photos. And two: as you can see, decent photos can come from original photos that are, frankly, mediocre at best.

The costume and doll prop aren't particularly hard to come by, and they don't make or break this image either. Be creative: A frilly summer dress and a stuffed animal could give the same effect.

The tricky thing here is the lighting; but take a closer look. It is very soft but quite directional light, coming from above and to the right of the model. I'm sure you can think of several ways to accomplish this sort of lighting, whether artificial or natural. In the case of this photo, we were underneath an outdoor stairway, and the light is sunlight, which was diffused by the clouds and by a building on the other side of the model.

Finally, a touch of post-processing: increasing the contrast, applying a blue filter on top of a black and white conversion—all standard stuff.

Sure, it's not the best photo that was ever taken, but I hope it illustrates the thought process you could use to learn more about photos taken by your favorite photographers.

Learning from your own photos

You can learn from your own photos in much the same way as you would learn from photos taken by somebody else. Of course, it can be tricky to be objective enough of your own photos to be able to take them apart, but you will always learn *something* if you are willing to critique your own work.

One trick you can pull is to open up your photo on a computer and flip it along the vertical axis. You're now looking at a mirror image of your original photo. I often look at my photos this way before I decide whether or not I am going to use them for anything. It helps me see them from a different side (literally!), and sometimes the flaws in an image will just spring out at you from this perspective. The opposite is also true: you may discover things you like about a photo that you hadn't even noticed before.

The other thing you could do is to make a point of finding one thing you would like to improve about every single photo you take— even the very best ones.

I'm not the greatest of photographers, but the trick about getting much better at what you do is to do everything consciously—even things that are instinctive. What I mean by that is if you feel you need to change a setting or a lens, go ahead and do it. But revisit that decision later: Find out why you felt that what you were doing was the right thing to do. "Just because …" is not a valid reason. There was something that made you feel that you could improve your photo in one way or another.

Feelings are extremely valuable. That's your experience talking, and you have to talk back: It's a skill you can develop with practice. Why are you making a choice to make a change? What is wrong with the photos you are getting, and what will the effect be of making the change? The

When you start experimenting with lighting, try using a stuffed animal to begin with. They're a lot more patient than models, and you're going to need all the patience you can get.

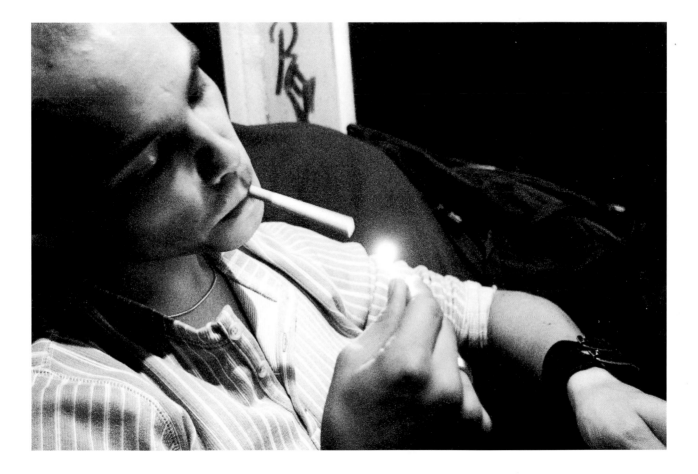

answer to those questions will help you develop and become a better photographer. But you have to be conscious about it. Write down your honest responses to hard-to-answer questions about your work, add them to your Flickr notes, and talk to other photographers about your choices. It doesn't matter how you do it, but make sure you vocalize it. The next time you're in the same situation, the perfect photo will roll out effortlessly.

I'll be honest with you. I've never taken a perfect photo.

But that's not the point. You become a better photographer by polishing one aspect of a photograph each and every time—and, hopefully, the photos you take will be closer and closer to perfect for every day of shooting.

Where to turn for inspiration

If you take away one thing from this book, it is that you really ought to share your photos with people. Stick them in an album and show them off at your place of work, put them on Flickr or Facebook, get them displayed in a gallery, talk to the landlord of your local pub or the manager of a local coffee shop and see if they won't stick 'em on the walls.

Whatever you choose to do, it's a good idea to ask people what they think of your photos. You don't have to agree with them—you don't even have to think that their opinions are sane—but it's always interesting to see what kinds of things people pick up in your photos. Maybe you're missing something?

Similarly, if you're spending time looking at photos others have taken, you're not wasting your time. Go out and explore.

Flickr.com

Fantastic for everything
from absolute beginners
to the hottest professional
photographers. Find someone
who is roughly on your level,
and start following his or her
work. Give feedback and see
what happens! (I'm on flickr
.com/photocritic).

deviantart.com

deviantART is great for all sorts
of art, but its photography
section is wonderful for a
gentle introduction to getting
critiques. It's a welcoming
community, which helps!

photosig.com

A site developed especially
to facilitate photography
feedback. There are a lot of
needlessly harsh critics on
photoSIG, but I find it great
for finding some photos I
like and seeing what other
photographers have critiqued
in the past.

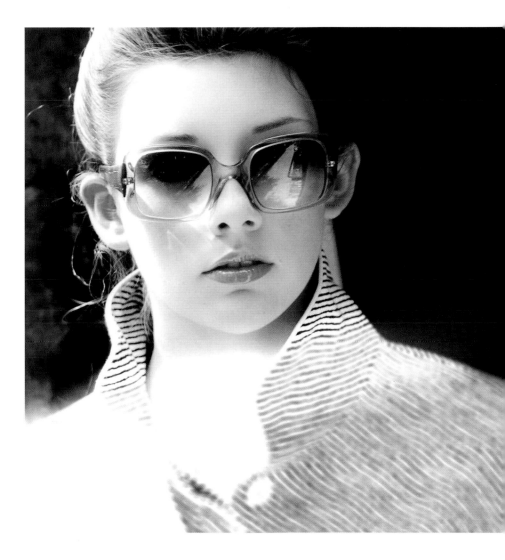

Index